BOSTON BEER

BOSTON BEER

A HISTORY OF BREWING IN THE HUB

NORMAN MILLER

FOREWORD BY KERRY J. BYRNE

AMERICAN PALATE

Published by American Palate
A Division of The History Press
Charleston, SC 29403
www.historypress.net

Front cover: *Courtesy Bill Damon.*

First published 2014

Manufactured in the United States

ISBN 978.1.62619.497.7

Library of Congress Cataloging-in-Publication Data

Miller, Norman, 1974-
Boston beer : a history of brewing in the Hub / Norman Miller.
pages cm
ISBN 978-1-62619-497-7 (paperback)
1. Beer--Massachusetts--Boston--History. 2. Breweries--Massachusetts--Boston--History. 3.
Boston (Mass.)--Social life and customs. I. Title.
TP577.M56 2014
338.4'7663420974461--dc23
2014010144

Notice: The information in this book is true and complete to the best of our knowledge. It is offered without guarantee on the part of the author or The History Press. The author and The History Press disclaim all liability in connection with the use of this book.

CONTENTS

FOREWORD

Boston is the self-described "Athens of America" and "Hub of the Universe." The city has long prided itself as a global leader of education, science, industry and innovation.

Our New England forebears relied on Yankee ingenuity and hard labor to create new and better ways to harvest fish from the ocean, granite from the ground, lumber from the forests and ice from rivers and ponds. New England ice, in fact, helped revolutionize the global food and drink trade in the 1800s.

We even pioneered ways to brew a better beer—a tradition that continues today in gloriously tasty fashion.

These most basic resources—fish, stone, lumber, ice—turned Boston into an economic powerhouse of great wealth and global reach that outpaces the city's relatively humble size. Boston, you might say, punches above its economic and cultural weight class.

It's no coincidence that our little corner of the planet, on the physical and cultural fringe of the United States, punches above its weight class on the global beer stage, too. After all, Boston is one of the best places in the world to enjoy great brew.

Hardworking Bostonians have loved to drink and to brew beer quite literally since European settlers first set foot in the region, as Norman Miller chronicles so well in his great new book.

Our thirst for tasty beer has grown through the centuries with our rising economic fortunes and standard of living. Bostonians today boast one of the world's most sophisticated beer palates: great local breweries turn out every

imaginable beer style, while most European export brewers count Boston as one of their largest overseas markets.

This is no accident of history. In fact, there is a direct correlation between our wealth and education and our thirst for world-class beer.

Beer is an accessible, easy-drinking product. Anyone can enjoy a good pint or can of beer, without affectation or elitism. Who doesn't love to throw back a couple icy cans of lager after a long day of work in the sun? There's a reason the hardworking everyman is known in the American lexicon as Joe Six-Pack.

But it's a mistake to classify beer as a simple product for the everyman. We can also sit back and appreciate beer for its subtlety, nuance, sophistication and variety, as consumers do in ever-increasing numbers, especially young adults.

Beer, you see, is and always has been one of mankind's great luxuries.

Beer is low in alcohol compared to pretty much all other forms of adult liquid enjoyment. So it's a largely expensive and inefficient way to transfer the desired joys of drink from raw materials to production to consumer.

Tipplers get a big bang from a liter of booze; not so much a liter of lager.

As a commercial product, beer requires bulk methods of production and storage and advanced systems of trade and transportation. All those capabilities require advancing wealth. And around the world, beer consumption has typically risen with economic fortune. Boston has long been a leader in industry, transportation and economics. So it only stands to reason that we've long been a leader in brewing and beer drinking.

The liquid that we call beer is also quite a bit more complex than its working-class image would have you believe. Beer, even at its most basic, is a complicated balance of bitter spices, typically hops, and sweet liquor from grains that are first malted and then mashed with hot water to release their sugars. Only then is it fermented and conditioned. It takes more ingredients, more equipment, more processes and more science to create beer than it does wine or other forms of alcohol.

As a result, the variety of tastes, colors, flavors and ingredients found in beer far outpace those found in other alcoholic beverages. The sophisticated consumers of today are thrilled by the variety, the flavors and the culinary experiences that beer provides them. It's quite common these days to sit at the bar at a nice restaurant and hear customers question the bartender about hop varietals in a new beer.

Beer production suffered in Boston, as it did all around the country, from the effects of Prohibition in the 1920s and then the consolidation of the beer industry (and other food industries) in post–World War II America.

In fact, the booming local industry was eventually reduced to almost nothing. But this downturn proved only a brief blip in New England history.

Boston in the 1980s began to recapture its rightful place as a center of the American beer industry, as one of the leaders of what we've come to call the craft beer movement.

Local businessman Jim Koch, the founder of the Boston Beer Co., reintroduced the nation to full-flavored domestic lager with the release of Samuel Adams Boston Lager in 1984. It took the nation by storm. Today, the Sam Adams pilot brewery and visitors' center in the Jamaica Plain neighborhood is one of Boston's most popular tourist attractions. Critics are too quick to point out that most Samuel Adams beers are made elsewhere. Regardless, Bostonians treat and drink Sam Adams as one of their own, the company offices are in South Boston and Koch is a beloved local celebrity.

I remember my first sip of Boston Lager around 1987 or 1988, a story I've shared with Koch over the years. I was at my girlfriend's house senior year in high school. Her older brother was drinking Sam Adams and offered me a bottle. I was shocked by the flavor and remember making a face and calling it "Yuppie beer." I grew up in a working-class family of Budweiser drinkers. That's what we drank, and we wore the brand loyalty with pride, like you would as a Ford or Chevy family.

But remember, almost all Americans at that time who came of age in that downturn of the U.S. brewing industry, regardless of socioeconomic condition, had never tasted anything other than mass-produced domestic lager. We simply did not know what hops and malt tasted like! I've since made up for lost time.

In 1986, not long after Boston Lager hit the market, a pair of enterprising and visionary Harvard Business School graduates, Rich Doyle and Dan Kenary, opened the humble Harpoon Brewery on the broken-down waterfront of Dirty Old Boston.

The turning point for Harpoon came in 1993, when it introduced Harpoon India pale ale as a summer seasonal beer, at a time when few Americans had heard of the well-hopped beer style. Bostonians fell in love with it.

Harpoon IPA proved so popular that it quickly became a year-round beer and today is Harpoon's flagship product and one of the best-selling IPAs in the world. More importantly, Old World India pale ale has since become the definitive American craft-beer style, brewed from coast to coast and spawning an amazing array of innovative spin-offs: double IPA, imperial IPA, white IPA and black IPA, to name just a few.

Like the British did with American rock 'n roll, Americans have taken British-import India pale ale, reimagined it and made it our own.

Harpoon has expanded dramatically since I first visited it twenty-odd years ago and has become one of the largest breweries in the nation. It hosts huge beer festivals several times a year, and perhaps most impressively, Boston's gorgeous new Seaport District has grown up around the brewery: glitzy high-rise hotels, office towers and restaurants have replaced the rundown waterfront warehouses of Dirty Old Boston. The sparkling Harpoon beer hall, which opened in 2013, offers plenty of suds, awesome oversized pretzels and a catbird's-seat view of the bustling city.

Boston remains the only major city in America that supports two of the nation's largest beer makers—a fact alone that says volumes about the city's thirst for good beer.

Keep in mind there are also about one hundred other breweries in New England, making it one of the most dynamic beer-brewing regions in the world. Almost all these breweries sell their beer in Boston or can be tasted with a few hours' drive.

One of New England's newest beers is Spencer Trappist Ale, brewed at St. Joseph's Abbey, in Spencer, Massachusetts. It just hit the market in January 2014. St. Joseph's Abbey is the world's first Trappist brewery outside Europe. The Pilgrims landed on Massachusetts shores in 1620, seeking freedom to practice their form of Christian faith. They drank beer for sustenance. Nearly four hundred years later, a Massachusetts monastery sells beer to fund and sustain its Christian faith. We drink their beer for fun.

Back around 1989, as students at Boston College, my friends and I began to visit a new place called Sunset Grill & Tap in Allston, a fun, hard-drinking Boston neighborhood filled with young people at the crossroads of the city's major universities. Sunset offered free food at midnight ("Midnight Madness," which is still offered today) and about twenty beer taps—something unheard of at the time.

We were thankful for the free food. We were amazed by the beer variety. Today, even neighborhood dive bars in Boston offer twenty taps. Back then, in the 1980s, it was revolutionary. If you wanted Samuel Adams Boston Stock Ale or the original Harpoon Ale (two long-gone Boston beers) or Sierra Nevada Pale Ale and Anchor Steam from California, Sunset was about the only place to try them all.

Sunset has since grown into a landmark of the American beer scene, with some 450 different beers. Scores of brewers in New England and around the country have Sunset owner Marc Kadish to thank for pouring their beers before anybody else would.

The changes in the Boston beer scene and the national beer scene really picked up pace in the 1990s, with the first full-blown American craft beer craze.

New breweries seemed to open in and around Boston almost every month. But many of the styles were still new to most folks; the beers and the brewers, meanwhile, simply weren't as a good out of the gate as new brewers tend to be today. Many died out with barely a whimper.

Boston brewer Dann Paquette makes spectacular world-class American artisanal ales today under the Pretty Things label and has built a loyal following for his cleverly branded beers. In the 1990s, he was honing his craft at the short-lived North East Brewing Co., a brewpub in Allston. The beers were good—just not as good as his beers are today. But the taste of his vanilla-tinged oak-aged porter, long before barrel aging became "a thing" in the beer world, has stuck with me through the years.

Hand-pulled cask ales are fairly common these days at good pubs and restaurants. Twenty years ago, Commonwealth Brewing Co. near Boston Garden was one of the only places in America where you could find hand-pulled English-style cask bitter, long before the New England Real Ale Exhibition became a regular event on the Boston beer circuit.

The beer was brewed in the basement in open, square Yorkshire-style fermenters. Tod Mott was one of the brewers there. He's perhaps best known for New England cult-favorite Kate the Great, an imperial stout he brewed during his days at Portsmouth Brewery in New Hampshire.

Long ago, Mott was the brewer at Harpoon, when the brewery was so small that he also hosted and poured beers for visitors in the small taproom. His beers were big, brash and unrestrained. He was brewing "extreme" beers long before the public palate had developed a taste for them. His idea for an innovative hoppy ale became the foundation of Harpoon IPA. He later crafted hefty stout at Commonwealth and then at Back Bay Brewing Co. on Boston's tony Boylston Street. I believe it was called Boston Strangler Stout, if memory serves correct.

Back Bay Brewing eventually ceded way to Forum, the restaurant made infamous in April 2013 as the site where the second bomb blew up during the Boston Marathon.

The craft beer and brewpub movement appeared to fizzle by the early 2000s, though leaving us certainly better off as beer consumers then we were before. But this was only a chance to retrench and take stock of lessons past. A new generation of brewers has picked up the torch here in Boston and around the nation in recent years.

Full-flavored domestic lager, hoppy IPA and Belgian farmhouse ales all seemed so new and exotic to us as young adults in the 1990s.

Young adults in Boston and elsewhere today grew up in a world in which these beers always existed. They are simply more sophisticated consumers than we were twenty years ago. Young brewers, of course, grew up in that same world. To put it bluntly: they are better at their craft than were the willing pioneers who tried, with varying degrees of success, to reinvent the Boston and the American beer scene twenty or twenty-five years ago.

These young brewers and young consumers have helped break down the last great barrier left facing the craft-beer movement: the fine dining scene.

There once was a time when high-end restaurants served only wine and spirits. It was quite common to visit a hot new restaurant and find a world-class wine list and a beer list that consisted only of Molson and Heineken, chosen simply because they were imports and assumed to be better than American beer. Servers were clueless. So were chefs and owners.

It was an extraordinarily frustrating period for beer drinkers who loved good food AND good beer. Good was out there. It was being brewed. It just wasn't being served at great new restaurants. I remember fighting with old-school food editors and chefs, asking the former why they didn't write about beer and the latter why they didn't serve good beer.

The food community simply did not know any better—and they should have. In fact, the folks who ruled the culinary scene around America were way behind the times for a good decade or more. The American public was turned on by these great domestic beers long before the culinary community caught on.

One of the inflection points for me personally, but also I think for the industry in general, came in 1998, when former *Boston Herald* food editor Jane Dornbusch brought me on to write the paper's first beer column. I had been writing for years for trade publications like Boston-based *Yankee Brew News*. Every newspaper in America had a wine column; nobody had a beer column. The pugnacious *Herald* was one of the first big-city dailies in America to offer a regular beer column.

I also convinced outlets like *Boston Magazine*, *Yankee Magazine* and *Esquire* magazine to let me write about beer at a time when beer writing was largely restricted to trade media. Each time, the biggest challenge was not convincing editors that I could do the job; it was convincing them that beer was something to write about. The food community, the people we expected to know better, was utterly clueless.

It's a different and better world for beer lovers now and for the culinary community at large.

Today, Norman Miller's "Beer Nut" column might be read in one hundred different newspapers. I'm jealous! And you can't be a serious food writer, food editor, bar manager or chef in Boston if you don't know good beer.

To this day, I rarely write about restaurants with bad beer lists. There's simply no excuse in the contemporary dining scene, especially in Boston, to serve great food without great beer.

Garrett Harker is one of Boston's preeminent restaurateurs and culinary trendsetters. He pictured beer as a part of high-end dining back in the 1990s when he was the general manager for famed Boston chef Barbara Lynch at No. 9 Park, a beautiful restaurant kitty-corner to Boston Common and the gold dome of the Massachusetts State House.

The restaurant was serving beers like Saison Dupont long before other restaurants copped on to the idea that it was a nearly perfect food-friendly beer. Then in 2005, Harker opened Eastern Standard, a hugely popular Parisian-style brasserie in Kenmore Square. It's nationally renowned for a cocktail program headed by Jackson Cannon, who complements the experience with a world-class "reserve" beer list.

Harker opened Row 34 at the end of 2013, in the rapidly gentrifying Fort Point neighborhood. It's a self-described "working man's oyster bar." The description, like the description of beer as a workingman's drink, is unnecessarily humble.

Row 34 is a sophisticated seafood restaurant owned by serious restaurateurs that also boasts one of the world's great beer lists. It's a great list not by virtue of its length but by virtue of its sophistication and nuance—a collection of carefully sourced beers, mostly from small local, national and international producers who attempt to replicate or reinvent classic farmhouse and artisanal beer styles. One of those producers is right across the street: Trillium Brewing Co. began brewing artisanal farmhouse-style ales in a reclaimed old brick warehouse in the heart of Boston in 2013.

Twenty-six-year-old bar manager Megan Parker-Gray told me soon after opening that she "curated" the beer list. I was thrilled to hear her choice of words: there was a time when only snooty sommeliers curated drinks lists. Today, beer lists are carefully curated by young women who never knew a world without artisanal farmhouse ales at their local pub, package store or restaurant.

Beer has always been a sophisticated luxury item. Today, it's finally been accepted as such in the dining community, at least here in Boston.

Norman tells us how we got to this glorious point in Boston brewing history in the pages that follow.

—Kerry J. Byrne

PREFACE

B oston is where I learned about beer.

I was a beer hater for most of my life—I was the kind of person who went to college parties and brought bottles of Captain Morgan's Spiced Rum or Jack Daniel's and Coca Cola. I hated the taste of beer. To me, it tasted like badly flavored carbonated water. It wasn't a pleasant beverage, and if I wanted that, I could get tonic water for much cheaper.

Things began to change in the late 1990s. I discovered a brewpub in Laconia, New Hampshire, that showed me that beer could have flavor—and more, it could be fantastic.

But, it wasn't until the early 2000s that I really learned about what craft beer really could be like. With my good friend Charlie Breitrose, we spent many a Saturday afternoon at the Sunset Grill & Tap in Allston. The Sunset Grill has 113 beers on tap and hundreds of bottles and cans of good beer, and it was my goal to try to drink them all.

I began devouring the beer list, trying as many different ones as possible. I even earned free glasses and a T-shirt because I drank so many beers there over the years. I grabbed hoppy beers from California. I grabbed crazy beers from Delaware or high-alcohol triples and quads from Belgium.

However, when I drank at home, I often fell back to beers brewed in Boston. Samuel Adams Boston Lager and Harpoon Brewery's IPA were two staples of my beer drinking over the years. The problem was, that was it. Boston. Boston and the surrounding communities weren't locations that I thought of when I thought of good beer.

I didn't understand the relevance both of these breweries had to the craft beer revolution. Jim Koch's Samuel Adams Boston Lager helped put craft beer on the map. Love it or hate it, you can't discount what Boston Beer Company did to bring craft beer to the public's consciousness. It was the first—and pretty much still the only—brewing company to run national ad campaigns. Samuel Adams Boston Lager introduced a generation of people to what later became known as craft beer. Without that attention they got, no matter what some of the established breweries thought of contract brewers, craft beer wouldn't have advanced how far it has today.

The same can be said with Harpoon, particularly on the East Coast. It introduced India pale ales, those hoppy beers that nearly every brewery in the United States brews, and hefeweizens, wheat beers, to New England. At the time, English-style ales dominated the portfolios of nearly all of New England craft breweries. This opened up the eyes of brewers that you could brew something other than ESBs, pale ales and Irish stouts, and beer fans would drink it up.

I began writing about craft beer in 2006, and since that time, Boston Lager and Harpoon IPA rank near the top of the beers I have most drank since then. Not only are they historically important, but they are also darn good beers.

Massachusetts is currently on an upswing of breweries opening. Harpoon got brewery license number one in 1986. Today, there are more than seventy brewing companies in Massachusetts—brewpubs, brick-and-mortar breweries and those that followed in Samuel Adams' footsteps and contract their beers. If it wasn't for Boston Beer Company and Harpoon, this wouldn't have happened. They paved the way.

Even though beer is growing in popularity, Boston only had one other brewery, Trillium, along with the two Boston Beer Works. Boston's growth is not matching the rest of the state—maybe it's a combination of property values and the red tape trying to start a business in the big city, I don't know.

It's almost sad that there are only three breweries in Boston. If you look back to the 1800s, you'd see that Boston was a brewing Mecca. The large number of Irish and German immigrants wanted the beer, ales and lagers that were part of their daily life in their home countries, and businessmen provided it for them. At one point in the 1800s, Boston had the most breweries per capita in the United States.

I had heard of the Haffenreffer brewery, but I never knew there was another Boston Beer Company. I didn't know there were large lager breweries like Roessele or that Jamaica Plain was a hub of brewing because of the Stony

Brook, which I always thought was just a name of a street. It's a history that is nearly lost, but hopefully, it will live on, in part in this book.

Hopefully, one day, Boston can reclaim its spot as one of the top brewing locations in the whole country as it did in the late 1800s. Hopefully, one day, when people talk about the top beer cities in the country, Boston will retake its position near the top of that list. Boston craft beer drinkers will support new breweries if they are built.

Until then, join me in enjoying a Samuel Adams Boston Lager or a Harpoon IPA or a Fort Point Pale from Trillium. Cheers!

ACKNOWLEDGEMENTS

Writing *Boston Beer: A History of Brewing in the Hub* was a fun experience, and I have a lot of people to thank for helping me make this book come to life. They shared some fascinating stories, and I hope I'm able to capture the stories in a way to make it fascinating to you.

First, I need to thank Tabitha Dulla and The History Press for giving me this opportunity. She deserves an award for being able to deal with me.

I also want to thank all of those who took the time to speak to me, especially Jim Koch of Boston Beer Company and Rhonda Kallman of Boston Harbor Distillery for taking the time to talk about a few decades of Samuel Adams history. I had known a lot of it from writing about Samuel Adams for years, but I still learned a lot that I didn't.

Rich Doyle and Dan Kenary of Harpoon were nice enough to take the time out of the day to share the history of Harpoon. It's amazing to me that, throughout their decades in business, they're still coming out with some excellent beers. They are not resting on their laurels.

Trillium Brewing Company does not have a long history yet, but Esther Tetreault, co-founder along with her husband, J.C. Tetreault, shared the trials and tribulations they went through to bring this excellent new beer to the masses. Trillium is too good of a brewery not to be successful and not to be around for years to come.

And I also need to thank Joe and Steve Slesar, who had some great stories about the early days of the Beer Works, which has grown to one of the most popular collection of brewpubs in the entire country. It's funny—I've bent

my elbow there numerous times throughout the years, yet I knew nothing about its early days.

I also need to thank Tod Mott of the soon-to-be-opened Tributary Brewing in Kittery, Maine. He was a big help, sharing his memories of both his time at Harpoon and the brewing scene during the late 1980s through the early 2000s. I can't wait to see what he has brewing up in Maine.

Dann Paquette was a breath of fresh air, blunt and sometimes a potty mouth, revealing his true feelings about his time as a brewer in Boston and what he still sees as a lack of beer culture in Boston today. The beer business is not all unicorns and rainbows, and it's good to see someone express that.

A huge thanks goes out to Chris Lohring, now of Notch Brewing. He was a huge help, talking about not only Tremont but also the brewpubs at the time, as well as providing numerous photos to be used in this book. Young brewers just starting out would be smart to seek him out and talk about his experiences so they don't repeat the problems Tremont ran into.

Kerry J. Byrne, most known today for his website Cold Hard Football Facts, is the man when it comes to beer writing in the 1990s and 2000s, being named North American Beer Writer of the Year twice at the Great American Beer Fest. I feel proud that he would take the time out to write a foreword for this book.

I also want to thank Michelle Diamandis of Boston Beer Company and Merrill Maloney of Harpoon for helping to arrange interviews with their bosses, as well as helping me get ahold of dozens of photos. The behind-the-scenes people do a lot of work that us beer drinkers don't even know about.

Boston had a rich brewing history, with dozens of breweries claiming Boston as their home through the 1800s and early 1900s. Thanks to Michael Reiskind of the Jamaica Plain Historical Society, who was kind enough to spend a couple of hours sharing the information about these breweries that he has spent years collecting.

I also need to thank *MetroWest Daily News* editor Richard Lodge, who approved many, many days off so I could write this book.

Sara Withee deserves credit for being forced to spend a day in my car with me, driving all over Boston (and to nearby communities accidentally) as she took several photos for the book for me.

If it weren't for my good friend Nicole Simmons giving me her laptop computer after my computer died, this book would never have been finished.

And finally, I want to thank my aunt and uncle, Pam and Roger Breton, for all of the support they give me. The Breton family is my only family, and the positive vibes they sent me kept me going.

Oh, that probably shouldn't be "finally"—I want to give one last global thank you to all of the craft brewers, beer drinkers and those who have read my column, blog and previous book over the years. You all inspire me to keep writing, and I hope you enjoy this book. Thank you! Now grab a beer (from Boston, of course) and start reading. Send me a tweet @realbeernut and tell me what you think.

BREWING A REVOLUTION AND COLONIAL-ERA BEERS

It was December 1773, and the *Dartmouth* was in port with its shipment of tea to the Massachusetts colonies.

The Sons of Liberty did not want that tea unloaded. They were opposed to the Tea Act imposed on them by the British Parliament, seeing it as taxation without representation.

So, these Sons of Liberty, with members that included Samuel Adams, Paul Revere, John Hancock and other notables, met at the Green Dragon Tavern on what is now known as Union Street. There, they devised a plan. And on December 19, 1773, after a large meeting at the Old Meetinghouse, a group of colonists, many dressed as American Indians, stormed the *Dartmouth*, pouring the tea into the sea in protest.

Taverns, often with ale and porter made on-site or brewed at home by women sometimes known as alewives, played an important role in Colonial-era Boston and all other major cities of its times. They were the meeting places where news and gossip was swapped, and they were also the places where those who wanted secrecy could meet in private, away from prying ears.

"Undoubtedly, if the secret history of the revolution were written, it would show that its initiatory movements were planned within the walls of this 'nest of treason,'" author Reverend Edward G. Porter wrote in his 1886 book, *Rambles in Old Boston*, which detailed many of these early pubs that existed in Boston prior to, during and after the Revolutionary War.

Beer or, more precisely, ale was an important part of the colonial life. Many men drank it daily, as it was safer to drink than water, and ships would

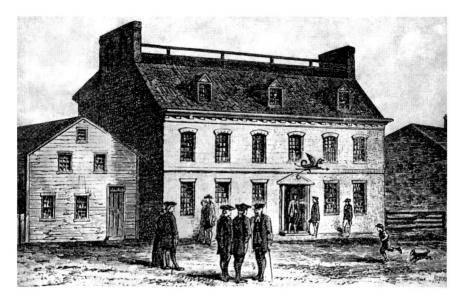

A sketch of the original Green Dragon Tavern, where the Sons of Liberty frequently met. *Photo courtesy of the Boston Public Library.*

often stock up on ale brewed in Boston prior to leaving dock and making their way to England.

The first recorded tavern in Boston was the Red Lyon, according to Gavin Nathan's 2006 book, *Historic Taverns of Boston: 370 Years of Tavern History in One Definitive Guide*. The tavern, which was also listed as a "brew house," was located near the Red Lion Wharf of North and Richmond Street. The tavern existed through the 1700s, and Paul Revere once made a sign for the pub.

Colonial-era breweries were not like those today or even like those of the 1800s. There were few commercial breweries, and most of them only produced small amounts of ale for those in the immediate vicinity.

The first brewing license in Boston (or what became part of Boston) was issued in 1630 to Robert Sedwick, who was the appointed captain of Charlestown.

"The license seemed like a bit of a formality seeing he had already set up a brewery had been brewing for sometime," according to Nathan's book.

Four years later, in 1634, Samuel Coal was granted the first license for a tavern, where it is believed he brewed his own beer, according to a March 30, 2012 Serious Eats article titled "Beer History: Boston."

Other early brewers were Seth Perry, who supplied barrels of beers to two different ships from 1685 to 1689, as well as barley to home brewers.

Another well-known brewer was Sampson Salter, who partnered with businessman Peter Faneuil (founder of Faneuil Hall) to become the most successful brewer of his era.

"Sales ledgers of the time from the wharf in Boston reveal frequent sales from Salter's Leveretts Lane brewery," according to Nathan's book.

Other early brewers included Robert Whatley, John Carey and Nathaniel Oliver, who built a brewery to supply his own ships, the book said.

"The location of these early taverns and brewing operations near the docks was no accident; beer was needed to supply the ships sailing between Europe and the colonies, and much of Boston's commercial brewing in the late 17th and early 18th centuries were aimed at maritime trade," according to the Serious Eats article.

According to the article, not all of the ales enjoyed at taverns were brewed locally. Because Boston was a port town, much of the beer was sent over from larger producers in England to the colonies.

Some of those early brewers may have been supplied by Samuel Adams (not a brewer) and his family, who were maltsters.

Although ale was enjoyed at home, it was also served at the early taverns, which were the main places to socialize.

"The tavern was a place to gather, have a pint of stout, share a newspaper, peruse the latest broadside or pamphlet and engage in friendly—or not so friendly—banter concerning the latest news and gossip," according to "A Place of Reading," an online publication by the American Antiquarian Society. "Newspapers were delivered by post to taverns and the literate patrons eagerly read them aloud to their illiterate neighbors."

The taverns were also a breeding ground for discontent. Educated patrons, upset with how the British Parliament was treating its colonial citizens, wanted a change. And it's at the taverns that they began planning on doing something about making things change.

"Imagine for a moment that you were a patron of Boston's Green Dragon tavern in the period leading up to the Revolutionary War and through the war itself," according to "A Place of Reading."

"From the vantage point of your table, the war would unfold before you in printed form and through heated debate. Discontent over the Sugar Act and the Stamp Act would provoke the ire of rum drinkers and readers alike. The Sons of Liberty would join you at your table, insisting you too boycott English goods."

Historian John C. Miller, in his 1936 book, *Sam Adams: Pioneer in Propaganda*, said the future namesake for Samuel Adams Boston Lager was one of those who most stoked the fires of revolution.

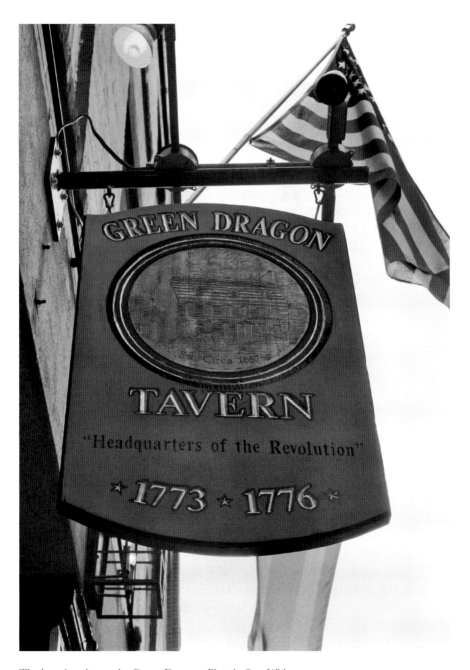

The hanging sign at the Green Dragon. *Photo by Sara Withee.*

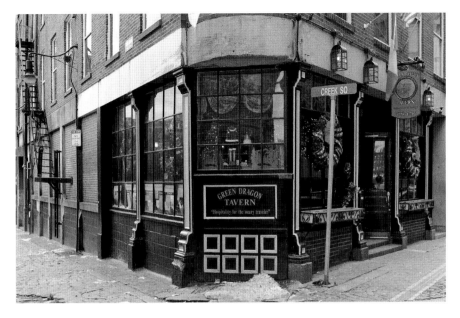

The front of the Green Dragon Tavern, which sits just outside of the popular tourist destination Faneuil Hall. *Photo by Sara Withee.*

"Adams dearly loved a pot of ale, a good fire and the company of mechanics and shipyard workers of radical political opinions," Miller wrote. "Under Sam Adams, Boston Taverns became nurseries of revolution, as well as 'Nurses of legislators.' He made the headquarters of the Revolution the Green Dragon Tavern in Union Street, where the Boston Caucus Club held its meetings and where the Sons of Liberty from near-by shipyards, rope walks and docks met to hear him hold forth against British Tyranny and the Tories."

The Green Dragon Tavern still exists today, although it is not the original building. The original building was torn down in the 1800s, and the new one is at 11 Marshall Street, right near Faneuil Hall.

The original tavern was built in 1654 and changed ownership several times. If you go to the Green Dragon Tavern today, there is a plaque outside that states that the original Dragon was the "Headquarters of the American Revolution." There may be some debate as to how much of the early Revolutionary War was actually planned there, but it definitely had a role, according to a 1798 letter Paul Revere wrote to Dr. Jeremy Belknap about the night of his famous "The British are coming!" ride.

"In the Fall of 1774 and Winter of 1775 I was one of upwards of thirty, chiefly mechanics, who formed our selves to a Committee for the

purpose of watching the Movements of the British Soldiers, and gaining every intelligence of the movements of the Tories," according to the letter (spelling and capitalizations are how they appeared in the letter). "We held our meetings at the Green-Dragon Tavern. We were so careful that our meetings should be kept Secret that every time we met, every person swore upon the Bible, that they would not discover any of our transactions, But to Messrs. HANCOCK, ADAMS, Doctors WARREN, CHURCH, and one or two more."

According to "A Place of Reading," after the Boston Massacre, in which British troops fired into a group of unarmed citizens, killing five of them, the Green Dragon became a place where the men "plotted revenge."

"Certainly newspapers, broadsides and tongues discussed the battle of Lexington and Concord and the start of the Revolutionary War on April 19, 1775," according to the American Antiquarian Society. "News couldn't reach the Green Dragon Tavern fast enough. Throughout America, the residents of other colonies rallied behind their Massachusetts brethren at war."

Even after the war started and before the masses fled Boston, the Green Dragon was where people gathered each and every day to keep track of the colonials' successes and failures.

"The Green Dragon tavern would provide news of all this and more," according to the American Antiquarian Society. "People talked, read aloud and silently, and prayed fervently for success. New England's taverns were truly Revolutionary reading places."

The Green Dragon is a much different place today. People still can grab a pint of ale, but instead of planning a revolution, they're eating such dishes as Redcoat Tenders and the Freedom Trail Combo Platter, or maybe a Paul Revere burger (bacon, cheese and sautéed onions) or a selection from its By Land or By Sea menu.

"Today The Green Dragon still plays host to a diverse and colorful clientele, though the practice of eavesdropping has long since stopped," according to the Green Dragon website.

Although the Green Dragon may be considered by many to be the most historically significant tavern in the Hub, others were also host to important events. The Bunch of Grapes Tavern, located on King Street, was one of those taverns.

The first Masonic Lodge in North America was founded at the Bunch of Grapes Tavern in 1733, according to the Massachusetts Foundation of Humanities. Famous members of the Masons included George Washington, John Hancock and Paul Revere.

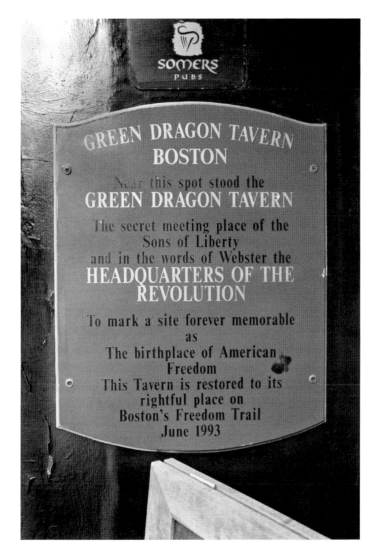

This sign is fixed on the outside of the modern Green Dragon Tavern in Boston. It explains its role in the planning of the American Revolution. *Photo by Sara Withee.*

The Bunch of Grapes Tavern was known as the "best punch house in Boston," author Edwin Monroe Bacon wrote in his 1903 *Boston: A Guide Book.* It also played host to many Whig (a now-defunct political party) meetings.

In their 1886 book, *Old Taverns and Tavern Clubs,* Samuel Adams Drake and Walter K. Watkins said, "When the line came to be drawn between

conditional loyalty, and loyalty at any rate, the Bunch of Grapes became the resort of the High Whigs, who made it a sort of political headquarters, in which patriotism only passed current, and it was known as the Whig tavern."

James Otis, a notable member of the Whig party and a lawyer who often wrote about the unfair practices of the British government, was severely injured one night after leaving the Bunch of Grapes.

"Otis, in attempting to pull a Tory nose, was set upon and so brutally beaten by a place-man named Robinson, and his friends, as to ultimately cause the loss of his reason and final withdrawal from public life," Drake and Watkins wrote.

The Bunch of Grapes Tavern remained popular even after the war. According to Bacon, after the British evacuated Boston, "Washington spent 10 days in Boston, [and] he and his officers were entertained here with an 'elegant dinner,' as part of the official ceremonies of the occasions."

Later, in 1789, army officers met at the Bunch of Grapes to organize the "Ohio Company," which settled Ohio.

One of the only colonial-era taverns to still be in its original building is the Warren Tavern, located at 2 Pleasant Street, in Charlestown. It was the first tavern to be built in Charlestown after the town was destroyed by the British during the Battle of Bunker Hill, according to an October 2012 *Boston Business Journal* article. The Warren Tavern was named after Dr. Joseph Warren, a Harvard-educated surgeon in Boston and a grand master of the Free Masons, a member of the Sons of Liberty and the one who sent Revere on his famous ride, according to Teach History, a website dedicated to teaching colonial-era history.

In 1775, Warren was killed by British soldiers during the Battle of Bunker Hill. Five years later, Warren's friend Captain Eliphelet Newell named the tavern after him.

According to the *Boston Business Journal* article, George Washington visited the Warren Tavern, and Revere, a close friend of Dr. Warren, would stop in for pints of ale.

The building is a Federal-style building, typical of the time period. It features low ceilings and a large fireplace. And according to the *Boston Discovery Guide*, a guide to the city of Boston, the bar features beams that were salvaged from the Charlestown Navy Yard.

Today, the Warren Tavern is your typical Boston bar, where you can go grab a beer, watch the game on a flat-screen television and enjoy some decidedly non-colonial-style food, such as crispy fish tacos or an Asian vegetable stir-fry.

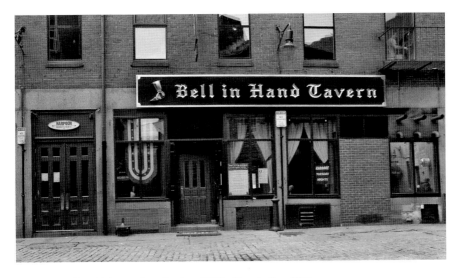

The Bell in Hand Tavern dates back to 1795. *Photo by Sara Withee.*

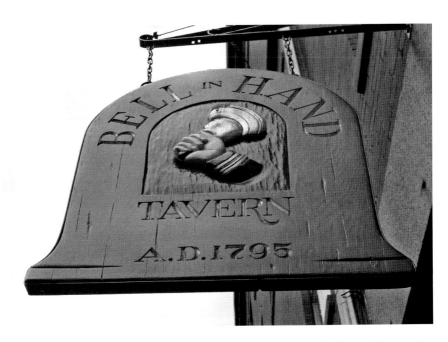

An older-style Bell in Hand Tavern sign. Taverns were known more for images than words in the 1800s. *Photo by Sara Withee.*

Another Boston landmark that lays claim to being "America's Oldest Tavern" is the Bell in Hand Tavern at 45 Union Street. It was built in 1795 by Boston's well-known town crier, Jimmy Wilson. The tavern, frequented by Revere and Daniel Webster, would not serve any hard alcohol and only served Philadelphia Cream Ale until 1919, according to the *Boston Business Journal*.

Although the current Bell in Hand is not in its original location (near Boston City Hall), it has been in the same spot since 1844. It is also located nearly across the street from the Green Dragon, near Faneuil Hall.

Another tavern that was popular during colonial times was the Sun, which was located on Batterymarch Street. There were other Sun taverns, but this is was the most famous, according to *Old Taverns and Tavern Clubs*. It featured a sign that said it had the "The best Ale and Porter Under the Sun."

Another well-known tavern was the Golden Ball Tavern, owned by Captain John Marston, who was a member of the Sons of Liberty and is said to have been one of the men who took part in the Boston Tea Party, according to David W. Conroy's 1995 book, *In Public Houses: Drink and the Revolution of Authority in Colonial Massachusetts*. Marston's tavern was large and featured many ornate trappings (including silver, many paintings and china) that other taverns did not. It was also a meeting place for the Sons of Liberty.

"Many of the sons could meet comfortably at the tavern since there were eighty-four chairs and seven benches," Conroy wrote.

So what about the ales that were imbibed while the Revolution was plotted? Beer was more than just a social lubricant. It was a way of life, dating back to the time when the Pilgrims landed at Plymouth Rock because they had run out of ale on the ship.

"Nearly every citizen of the day knew that drinking water could make you deathly ill," historian Gregg Smith said in his 1998 book *Beer in America: The Early Years*.

"Ale drinkers were somehow spared this affliction and therefore most people soon substituted a frequent imbibing of ale over the dread curse of the water," Smith continued.

Early beer drinkers in the United States did not know that the boiling of the water made the ale safe, and they could have done that with other water. All they knew was that ale was safe and water was not.

"So it was that a brew house was an indispensable priority in each new settlement," Smith wrote.

The importance of brewing even affected how homes were built, according to Smith.

"Although the young villages would soon witness the establishment of commercial breweries, it was in the home where most beer was produced," he wrote. "This home brewing even had its effect on colonial architecture. Most households added a small brew room into their living quarters."

Early colonists ran into another issue when they were brewing beer: ingredients. Hops were growing wild, but there weren't large fields of barley, used to produce the malts that provide the fermentable sugars that yeast turns into alcohol.

Instead, Lisa Grimm said in a May 10, 2011 Serious Eats article titled "Beer History: Swapping Homebrew Recipes with the Founding Fathers," early brewers used other sources of sugar.

"Residents of colonial America were not shy about brewing with additions that we might find peculiar today," Grimm wrote. "Potato beer was quite popular, with recipes for this 'excellent beverage' published in a number of sources. Potatoes continued to be a common addition to the brewing process in the nineteenth century."

Other common ingredients included molasses, ginger, spruce treacle and peas, Grimm said.

Most brewing was done by the wives, servants and slaves. George Washington had a famous recipe for a small beer, which Grimm said was considered "an everyday drink that might be consumed by children, servants and the infirm. If brewed strictly to his methods, the beer would clock in around the 11 percent (alcohol by volume) mark; the addition of ample amounts of molasses makes for a heady beverage."

Many of the country's founding fathers brewed beer. In 2006, Boston Beer Company released a special four-pack of beers based on colonial recipes, including the George Washington Porter, which was known to be the first president's favorite style of beer; the James Madison Dark Wheat Ale, which had wheat smoked over red and white oak from Madison's own land in Virginia; and the Traditional Ginger Honey Ale, supposedly brewed by Thomas Jefferson and his wife. The fourth beer was an alcoholic version of a root beer.

Today, one of the most popular seasonal beers is pumpkin ale. You can thank or blame (depending what you think about pumpkin beers) colonial-era brewers for that creation, Grimm said in her September 27, 2011 Serious Eats article, "Pumpkin Beer History: Colonial Necessity to Seasonal Treat."

"But the main reason pumpkin was adopted as a beer ingredient during the early colonial period was simple availability—pumpkins were a native plant (one completely unknown to most Europeans before the 16th century),

while good malt was not so readily available—fermentable sugars had to be found where they could, and in the first pumpkin beers, the meat of the pumpkin took the place of malt entirely," Grimm wrote.

To this day, pumpkin beers are still being brewed. Boston Beer Company, Harpoon and Beer Works all brew pumpkin beers. Beer Works has also brewed a potato beer.

The lack of traditional beer ingredients also gave rise to another popular alcoholic beverage: cider.

"Apple trees were not native to the new world but they grew well in the temperate climate," Smith wrote. "As the trees flourished, households took to producing an acceptable alternative to beer and the cider flowed. Indeed, it was an early favorite among the settlers and would remain so into the beginning of the 19th century. Although it was both easy to produce and popular, it was, after all, a substitute. For their first love, ale."

Ironically, with the roles that taverns played in the planning of the Revolutionary War, it was the English government that sought to have the taverns built in the first place, Smith said. It felt that taverns would serve as a focal point of trade and economic development in the colonies.

"As taverns were built, trade increased, and as trade brought in money more taverns were constructed," wrote Smith. "Even areas with little currency established taverns to function as commercial centers in a barter system. These farmers could trade produce for a supply of ale."

And then, the taverns became home for the Revolution, and Smith wrote, "Thus, part of the solution to development of the colonies, by encouraging the growth of taverns, eventually led to the end of British colonial America."

BOSTON BREWERIES OF THE 1800s

As the nineteenth century ended and the twentieth century began, Boston was a brewing hub. At the city's height, there were thirty-one breweries, including some of the largest beer producers in the United States, and it had the most breweries per capita in the country.

By the end of 1964, every one of those breweries was gone, as a combination of Prohibition and large, national brewers beginning to expand and making it impossible for smaller, regional breweries to compete.

At this writing in 2014, there are three breweries in Boston, as well as two brewpubs, but it wasn't always that way, according to the Jamaica Plain Historical Society, which has documented the twenty-four breweries that were located in the Roxbury and Jamaica Plain neighborhoods during the 1800s and early 1900s.

"Beer making in Boston was in its heyday in the early 1900s," according to the historical society's "Boston Lost Breweries," an article posted in 2004. "Try to imagine the clatter of horse-drawn, iron-wheeled wagons bringing raw materials in and finished product out of the 24 breweries in Roxbury and Jamaica Plain, which were located on or near Columbus Avenue, Heath Street and Amory Street. Add the pungent odors of hops, yeast, slowly cooking grains and the coal and wood smoke billowing from each of the 24 smokestacks and you begin to sense the impact these breweries had on their neighborhoods."

Boston was home to both a large Irish and German population, according to Michael Reiskind of the Jamaica Plain Historical Society. Although the

An ad for Alley beer, another long-forgotten brewery. *Photo courtesy of the Boston Public Library.*

Irish were typically ale drinkers and the Germans preferred lagers, the beers being produced did not seem to be split along nationality lines.

"The breweries seemed to be owned half by the Irish and half by the Germans," he said. "Some of the Irish ones just made lagers and some of the German ones just made ales."

Although there were breweries in several Boston neighborhoods, Jamaica Plain and Roxbury were the center of the industry in the 1800s. Reiskind said the Stony Brook, which provided an abundant source of water for the early breweries, was attractive to potential brewers.

"They needed the water source and they used the aquifer," he said. "The land was cheap and it was good water for brewing."

Boston breweries had to deal with two different periods of prohibition in the 1800s, and in 1918, Massachusetts again ratified prohibition, two years prior to the Volstead Act being passed nationally. When prohibition is mentioned below, it refers to Massachusetts' prohibition beginning in 1918, which resulted in the closure of most Boston breweries. The Volstead Act was repealed in 1933, but only four breweries remained active: Haffenreffer Brewing Company, Boston Beer Company, Commercial Brewing Company and Star Brewing Company.

After Prohibition ended, the few Boston breweries struggled to keep up with large regional brands, such as Narragansett from Rhode Island, or

national brands. These breweries were much more modern and had better equipment. Their packaging lines could pack a case a minute.

However, the city's earliest brewery was not in Jamaica Plain. It was located in the Charlestown section of Boston. The Bunker Hill/Van Nostrand's Brewery was founded in 1821 by John Cooper and Thomas Gould and was located at 40 Alford Street, which is a parking garage now.

The brewery was large and considered one of the most prosperous in Boston. The brewery's most famous beer was the P.B. Ale, which was mimicked by other retailers that would mark other beers with the P.B. label. The brewery sued several for trademark infringement and won in the Massachusetts Supreme Judicial Court, forcing others to stop using the P.B. name.

Van Nostrand was quite proud of its P.B. Ale, calling it a "mighty convincing" ale in a 1905 advertisement. The ad said, "It's the best ale brewed in any country. The man who knows when ale is ale recognizes P.B. as the real thing."

Other beers brewed included the Half and Half, which was a combination of its ale and porter, and the Old Musty Ale, which was considered the strongest beer of its time in the 1890s.

Bunker Hill/Van Nostrand's Brewery was the longest continuously run brewery when Prohibition hit. The brewery never came back, even after it was repealed.

Just a few years after Bunker Hill started, the original Boston Beer Company (not connected to the Boston Beer Company of today) was founded in 1828. Located in South Boston on West Second and D Streets (not far from the current locations of Harpoon Brewery and Trillium Brewing Company), the Boston Beer Company was the longest-running brewery in Boston history, surviving 129 years until it closed forever in 1957.

The Boston Beer Company specialized in low-alcohol and no-alcohol beer, such as the near beer Reliance, which helped the brewery remain successful throughout two different eras of prohibition in Massachusetts during the 1800s.

In 1877, Boston Beer Company actually sued the state of Massachusetts over the second era of prohibition. The company argued in front of the U.S. Supreme Court that the 1869 prohibition on alcohol prevented the Boston Beer Company from fulfilling its charter, which was approved in 1828. The suit was originally filed in state court after law enforcement officials seized a shipment of beer and did not return it to the Boston Beer Company. The suit wasn't heard until well after the second prohibition ended in 1875, but Boston Beer Company wanted to be reimbursed for what it had lost.

Unfortunately, the U.S. Supreme Court ruled against Boston Beer Company. The ruling said, in part, "A state law prohibiting the manufacture and sale of intoxicating liquors is not repugnant."

Boston Beer Company continued to be successful until 1918, when prohibition started. It survived by brewing its nonalcoholic beers and was one of only four Boston breweries still in existence when Prohibition was repealed in 1933.

But things were different after Prohibition. Consumers had lost their taste for ales. They wanted the lagers with less flavor being brewed by large breweries like Anheuser-Busch and Pabst. Boston Beer Company could not compete with the larger, more well-known breweries, and it closed its doors forever in 1957.

In 1846, John Roessle started the first all-lager brewery in the history of Boston, the Roessle Brewery, located at 1250 Columbus Avenue in Roxbury. Lagers were popular in Germany but weren't widely available in the United States until the lager yeast could survive the trip from Europe.

When Roessle started his brewery, the style had taken hold in areas with a large number of German immigrants, and the Roessle Brewery, which produced only three hundred barrels a beer in its early days, was a favorite of Germans living in Boston.

"First, its flagship beer, 'Taffel,' quickly became a favorite of Boston's German population," according to a February 1997 *Yankee Brew News* article. "More importantly, Roessle wasn't burdened with the expense of distribution; enthusiastic and loyal customers bought every drop from the brewery's doors. It didn't take long for Roessle to capitalize on the brand's popularity by expanding the brewery. In fact, each time production increased, sales rose equally."

Roessle ran the brewery until he died in 1885. His son, John Roessle Jr., ran the brewery for eleven more years.

In 1896, the New England Brewing Company, a consortium of breweries purchased by English businessmen who also bought the Haffenreffer brewery and the Suffolk Brewing Company, purchased the Roessle Brewery.

Roessle continued to grow, brewing as much as sixty-five thousand barrels of beer a year, before closing its doors for good when prohibition hit. The Haffenreffer brewery bought the Roessle brewery when Prohibition ended and used its facilities until 1951.

The next brewery to come to Boston was the Burkhardt Brewing Company, perhaps one of the most famous pre-Prohibition-era breweries in Boston. The Burkhardt brewery, founded in 1850, by Gottlieb Burkhart and

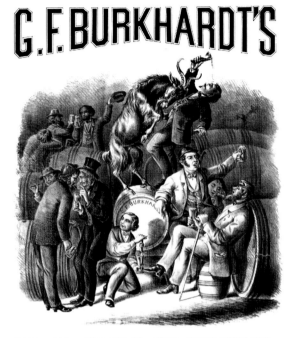

G.F. BURKHARDT'S

BOCK BEER

G.F. Burkhardt's ad for its Bock Beer, featuring the traditional goat. *Photo courtesy of the Boston Public Library.*

his son, Gottlieb Jr., was located at the intersection of Station and Parker streets in Roxbury.

The brewery was made up of two large buildings and a stable that created almost an enclosure for the Houghton and Company Vienna Brewery, which was also located in the same area (built seven years after Burkhardt opened).

Interestingly, the head brewer for Burkhardt Brewing Company was Rudolph Haffenreffer, a German immigrant who came to Boston after the Civil War. There, he met and married Gottlieb Burkhart's niece, and he left and started the Haffenreffer Brewery in Jamaica Plain in 1870 (more on that later).

"I don't think they were angry at each other," said Reiskind. "I think they were friendly competitors, and Mr. Burkhardt may have actually given him money to start the brewery."

The elder Gottlieb died in 1884, but the brewery was kept alive by the younger Gottlieb. It brewed several beers, such as Tivoli Beer, Extra Lager

Beer, Augsburger Lager, Augsburger Dark, Salvator Lager, Brown Stock Lager and Bock-style lager. Along with the 100,000 barrels of lager (a barrel equals thirty-one gallons) of lager it brewed, Burkhardt also brewed several ales, including the Golden Sheaf Ale, Cream Ale, Brown Stock Ale, Old Stock Porter and India Pale Ale.

It was also an early supporter of the Boston Red Sox. In 1912, it brewed the Red Sox Beer and the Pennant Ale in honor of the team taking home the World Series.

Like many other breweries, Burkhardt could not survive Prohibition. It remained in business until 1929, making cereal and other similar products, but finally shuttered its doors for good.

Today, the Burkhardt brewery is gone, and in its place is a large parking lot.

Around the time that Burkhardt Brewing Company started, the Bay State Brewing Company began brewing at 524 East Second Street in South Boston. It was founded by Henry Souther, who later sold it to Portsmouth, New Hampshire brewing mogul and politician Frank Jones.

Frank Jones's Portsmouth brewery was one of the largest in all of the United States, and the state politician expanded to Massachusetts. The new brewery was not quite as successful as his New Hampshire brewery, and it closed in 1903.

In 1857, the H&J Pfaff Brewing Company on 1276 Columbus Avenue, along the Roxbury and Jamaica Plain line, began operations. It was a lager-only brewery started by Henry and Jacob Pfaff, two immigrants from Bavaria. Jacob, the older of the two brothers, lived next door to the brewery, which was known for its company slogan, "Best brewed because brewed best."

In an advertisement that appeared in the *Harvard Graduates Magazine* in 1898, Pfaff's implored readers to drink its lager beers over all others, writing, "It is the best: it really is; for we are the only maltsters in Boston. All our malt we make from carefully selected barley. Therefore, we are able to guarantee our product as the best."

Like the Roessle Brewery, H&J Pfaff Brewing Company brewed lagers exclusively. Like most Boston-area breweries, Pfaff closed due to Prohibition. The brewery is gone today, and Roxbury Community College sits where H&J Pfaff once stood.

In 1900, the Massachusetts Breweries Company formed to fight the newly created New England Brewing Company, a British company that started purchasing controlling interests in several of Boston breweries. The independent breweries were concerned that the breweries, including Haffenreffer, would have too much money and control of the industry.

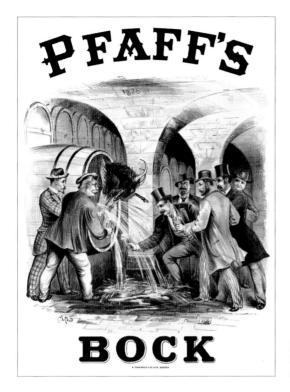

Pfaff's Bock advertisement also featured a goat. *Photo courtesy of the Boston Public Library.*

Pfaff's, along with nine other independent breweries, combined to form the Massachusetts Breweries Company. The move allowed them to compete with the New England Brewing Company on a financial level. The other breweries involved included the Continental Brewing Company, Norfolk Brewery, Elmwood Spring Brewing Company, Revere Brewery, Franklin Brewery, Robinson Brewing Company, American Brewing Company, Hanley & Casey Brewing Company and Alley Brewing Company, according to an August 8, 1901 *New York Times* article.

Charles Pfaff, who now ran the brewery, was named the president of the new organization and was a member of the board of directors. Even though the Massachusetts Breweries Company worked to protect its larger members, several of the smaller members or other small independent breweries that did not join were put out of business by the large conglomerate. Unfortunately, Pfaff, along with most of the other members of the Massachusetts Breweries Company, did not survive Prohibition.

The next major brewery to open in Boston was again in Roxbury: the Rueter & Alley Brewing Company/Highland Spring Brewery, which was

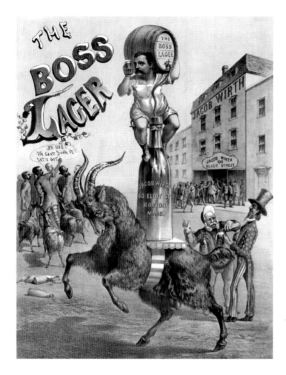

Jacob Wirth's, which still stands today, brewed its own beer, the Boss Lager. *Photo courtesy of the Boston Public Library.*

open from 1867 through 1918. The brewery was founded by German brewer Henry A. Reuter and Irish brewer John R. Alley.

Known as the Highland Spring Brewery (because of the wells it used to get its water from instead of the Stony Brook), by 1872, it was known as the largest brewer of ales and porters in the United States at a time when lagers had begun to dominate the industry. The brewery was made up of several buildings along Terrance and New Heath Streets. These buildings housed the brewery, a bottling plant, a storehouse for casks and tanks of ale and porter, as well as a large refrigeration building. The company was one of the first to add ice-making machinery to a brewery.

After the original partners split in 1885, the brewery was renamed Rueter & Company, while Alley founded his own brewery, also on Heath Street. Until Rueter & Company closed due to Prohibition, Rueter served as the president of the United States Brewers Association, which was a national trade group.

One of the brewery's major accomplishments was its Highland Spring Ale wining first prize at America's Centennial Exposition, beating all the entrants from New York and Philadelphia, considered two of the best ale-producing areas in the United States.

Even though Rueter & Company closed due to Prohibition, the Highland Spring Brewery would still brew beer when it was taken over by a new brewer after the end of Prohibition. The Croft Brewing Company was the only brewery to open in Boston after Prohibition ended in 1933. Former Highland Spring Brewery brewmaster Walter J. Croft bought part of the facility and brewed Croft Cream Ale and Croft Pilgrim Ale, which were popular canned beers. After it closed in 1953, it became a pickle factory, and today it has been renovated into high-priced housing.

The Croft Brewing Company made big waves once it opened its doors in December 1933. In its first full year of business, it made more than $4 million in net sales, according to a 1935 article from *Modern Brewery Magazine*, headlined "Today, Croft is America's Leading Ale."

"In the short span since Dec. 6, 1933, when the first shipment left the brewery, Croft Ale jumped into the leadership in ales and beers, not only in Boston, but throughout New England. It has held this leadership in sales ever since," according to the article. "No mean feat! According to a recent survey made by the *Boston American*, there are fifty-four ales and beers being marketed in Metropolitan Boston. Besides the competition of the big western brewers and the New York brewers, Croft has had to compete for supremacy with a host of local brewers, all of them marketing ales."

However, quality was the reason for Croft failing, said Milton Allen, a longtime member of the Massachusetts beer industry, in 1988's *Beer New England*, by Will Anderson. Allen blamed Croft buying a new coating for his aging tanks without testing it. The coating dissolved in the beer, exposing the ales to the iron tanks.

"Croft went down to nothing," the book quotes Allen as saying. "Then they came out with cream ale and so on and so forth, but they folded. And that was the incident that did it. One incident."

Not much is known about the Suffolk Brewing Company, which was founded in 1861 on Eighth Street. The brewery brewed both ales and lagers and advertised its "Munich Lager." According to *Beer New England*, Suffolk also brewed a nonalcoholic beer called Uno. Suffolk Brewing Company was one of the breweries purchased by the New England Brewing Company. The Massachusetts Breweries Company later purchased the Suffolk Company and eventually closed the brewery for good.

The Cook Brewery was originally founded in 1866 by Charles H. Nichols and Thomas Carberry but was sold to Patrick T. Hanley (who served as a colonel in the Civil War) and James D. Casey, who renamed it the Hanley

& Casey Brewery in 1884. It was known for brewing several different beers, including the stock ale, an old stock ale, an India pale ale and a porter. Hanley died in 1899, and in 1900, the brewery became part of the Massachusetts Breweries Company and closed within a couple of years.

The A.J. Houghton & Co./Vienna Brewery was founded in Roxbury in 1870, in the former location of the Christian Jutz brewery, which was built in 1857 but failed. It is known as one of the first breweries in Boston to use artificial refrigeration.

Originally, the brewery was located across the street, but it quickly moved to the Jutz property and used the original building to house its stable. Originally known as the Rockland Brewery, it brewed beer, but when its Vienna Lager became popular, it changed its name to the Vienna Brewery and converted to an almost exclusively lager brewery.

The beer it was most famous for was the Vienna Lager, a lighter German lager that was growing in popularity. It also brewed the Pavonia Lager Beer, Vienna Old Time Lager and Rockland Ale.

Although the brewery closed in 1918, a large portion of the brewery still remains today, one of the few in Boston to survive construction and avoid being torn down. The brewery, located at 133 Halleck Street, was protected from total demolition by the Boston Landmarks Commission.

After leaving Burkhardt's, Rudolph F. Haffenreffer Sr. bought the defunct Peter's Brewery along Bismarck and Germania Streets in Jamaica Plain and, in 1870, opened what became the most well-known brewery in Boston, the Haffenreffer Brewery. Haffenreffer, a German immigrant who came to Boston after the Civil War, originally called his brewery the Boylston Lager Beer Company, but because of the number of German immigrants, he did away with the name and named the brewery after himself.

The Haffenreffer Brewery quickly grew in prominence and size. The brewery expanded to fourteen separate buildings that included a tower building, a main brewery, stables and a bottling plant. Local rumors had it that there was a spout on the wall of the main brewery where people could come and get free beer if they wanted. Babe Ruth was allegedly a frequent visitor, filling pails of beer.

When Prohibition hit, Haffenreffer survived by brewing near beer, such as Dry Town and Pickwick Pale, as well as soft drinks and sparking water.

Haffenreffer continued to brew its lager and added the Pickwick brand of ales after Prohibition, as well as beers under the Boylston and Bayrisch labels. It also purchased the now-defunct American Brewing Company and Roessle Brewery.

In addition, Rudolph's sons also became part of the beer industry. His son Theodore married a president of the all-women's Wellesley College and lived next to the brewery,

Another son, Rudolph Frederick, after learning about the brewing industry, started his own brewery in Rhode Island, Narragansett Brewing Company (which was revived in 2006).

While Haffenreffer was initially successful after Prohibition, it had trouble keeping up with the national brands. By 1964, Haffenreffer closed its doors for good. The name was purchased and transferred to various breweries throughout the following decades. The Haffenreffer Private Stock Malt Liquor became a popular drink and is still produced today.

The Haffenreffer name is still well known, particularly in Rhode Island. Rudolph Frederick Haffenreffer had many interests that weren't beer-related, including collecting American Indian artifacts, as well as Eskimo artifacts. He also purchased a large tract of land in Rhode Island that was known as "the throne of King Phillip," where he put a dairy farm. When he died in 1954, the family donated all of the artifacts and land to Brown University, and today it is the Haffenreffer Museum of Anthropology.

As for the actual brewery, the Haffenreffer Brewery is the only Boston brewery from the 1800s to survive completely intact. The site is owned by the Jamaica Plain Neighborhood Development Corporation. Among its tenants is the new Boston Beer Company, also known as Samuel Adams. Samuel Adams is located in one of Haffenreffer's largest buildings, and there it brews beer, conducts tours, holds several special events throughout the year and houses a large brewery store.

Haffenreffer, like many other breweries in Boston, began feeling the financial pinch in the 1890s. The beer tax was increased, and national brands from the Midwest began to show up in Boston and the surrounding communities, taking away some market share from the Boston brewery.

In 1890, New England Brewing Company, an investment company, bought controlling interest in Haffenreffer, Roessle and the Suffolk Brewing Company, which resulted in several other breweries combining to form the Massachusetts Breweries Company.

The Robinson Brewing Company/Rockland Brewery was founded in Jamaica Plain in 1884. The brewery was most known for its Elmo Ale. The brewery was originally owned by John Alley, who opened it as the Amory Brewery in 1877. It was located at 55–71 Amory Street. Alexander Robinson purchased the brewery in 1884, and named its most popular beer after his son Elmo. The Robinson Brewery only remained open for a brief period of

time. The brewery had joined the Massachusetts Breweries Company, the large consortium of Boston breweries, but closed in 1902 after only eighteen years in business.

Portions of the brewery remain open. It became a tool company and later a futon factory. There are also several artists' lofts located there today.

The Alley Brewing Company, also known as the Eblana Brewery, was on Heath Street from 1886 through 1918, opened by one of the original founders of the Highland Spring Brewery. John R. Alley's brewery brewed the Eblana Irish Ale. The brewery was taken over by Alley's sons, Frederick and George, when he died in 1898. Like most of the breweries that never brewed beer after Prohibition, the Alley Brewing Company remained open throughout the time period when it became a Canada Dry Ginger Ale (nonalcoholic) bottling plant.

Although it was close to Alley's former brewery, Reiskind told the *Boston Phoenix* in a 1995 article that both breweries were successful. "People drank a lot of beer," he said.

The brewery was designed by Philadelphia architect Otto Wolf, and it featured seven separate bays and was made of brick and granite, half of which was polished into a checkerboard pattern.

The American Brewing Company, one of the driving forces behind the Massachusetts Brewing Company, opened for business in 1891 in Roxbury. The brewery was owned by beer magnate James W. Kenney, an Irish immigrant, who, along with the American Brewing Company, founded the Amory Brewery in 1877 on Amory Street, the Park Brewery on Terrace Street in 1882, the Robinson Brewing Company (mentioned above) and the Union Brewery, also on Terrace Street, in 1893. The Union Brewery was actually built specifically to be a lager brewery to capitalize on the growing demand for the style.

The American Brewing Company was by far the largest of Kenney's breweries, producing more than 100,000 barrels of beer a year. It was also the largest brewery that was part of the Massachusetts Breweries Company.

Although owned by Kenney, the American Beer Company was run by Gottlieb Rothfuss and his family. During Prohibition, it became a storage facility for wool and cotton. It is one of the few breweries that survived Prohibition, reopening at the end of 1933, when the Haffenreffer Brewing Company purchased it and used it as storage. However, the survival was brief, and it closed for good in 1934.

Reiskind said the American Brewing Company, architecturally, was considered one of the most beautiful in Boston. The three buildings that

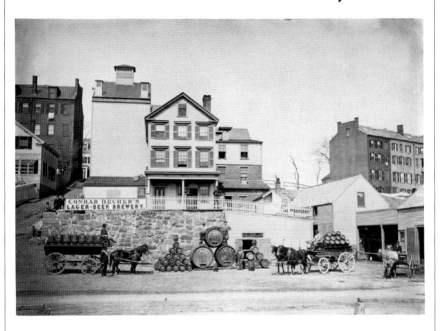

CONRAD DECHER,

LAGER BEER BREWER,
EAST BOSTON.
Office, Avon, corner Washington Street - - - BOSTON.

The Conrad Decher Lager Beer Brewery. This ad depicts horses getting ready to deliver barrels of beers. *Photo courtesy of the Boston Public Library.*

made up the brewery wrapped around a beautiful cobblestone courtyard, and the buildings featured stained-glass windows, as well as decorative clocks on top of the buildings. The main building featured terra cotta and ornate brickwork, as well has half-moon transom windows.

Today, the main portion of the American Brewing Company remains standing, with developers taking advantage of its large spaces and high ceilings to develop a high-end apartment complex called the Brewery Lofts.

Kenney's Park Brewery was located on Terrence Street and brewed Irish ales exclusively. The brewery was in operation from 1881 to 1918. Most of it was torn down to make room for a construction project in connection to the Orange Line.

Kenney's other brewery, Union Brewing, was located at 103 Terrance Street. Like the Park Brewery, which only brewed one style of beer, Union Brewing only brewed one style, German lager. Several portions of the building remain today, including a smokestack, which is also used as a cellphone tower.

The Roxbury Brewing Company was a short-lived brewery, only surviving for four years, from 1895 to 1899. The owner, William T. Titcomb of Providence, Rhode Island, sold the building to Rueter & Company, which went on to brew about 125,000 barrels of beer in the facility before it closed. Located at 31 Heath Street, the Roxbury Brewing Company building is now home to Family Services of Greater Boston, a local health and social service organization.

In 1897, the Puritan Brewing Company opened its doors in Charlestown and remained active until it was sold and renamed the Commercial Brewing Company. It brewed ale, porters and lagers and survived Prohibition. However, Commercial Brewing Company could not compete with larger breweries and closed its doors in 1940. The original founder of Puritan was John Devine, who died as the large brewery was being built. It was the last brewery in Charlestown until the Tremont Brewery opened in 1994.

The Franklin Brewery started brewing beer the same year as the Puritan Brewing Company and got its name from the nearby Franklin Park. Like the American Brewing Company, the Franklin Brewery was considered an architecturally beautiful building. The brewery stood six stories above nearby Washington Street and nine stories above Haverford Street. Chicago architect Charles Keastner designed the building to look symmetrical by using arches. Franklin Brewery was most known for its XXX Ale and Stock Ale, and it brewed as much as forty thousand barrels a beer for a year before closing for Prohibition. In 1918, it became a storage house, and today it is home to Extra Space Storage.

The Habich & Company Brewery (also known as the Norfolk Company) was open from 1874 through 1902 at 171 Cedar Street. Like Pfaff's, the Habich & Company's building is gone, as it was torn down to make room for Roxbury Community College. It was one of the breweries that joined the Massachusetts Breweries Company and was closed by the group.

Habich & Company made several beers, according to an advertisement that appeared in the *Harvard Graduates Magazine* in 1898, which read, "The Norfolk Ales and Porters have gained their reputation for 'Purity and strength,' through our always adhering to our trade-mark and manufacturing ales and porters which in regard to quality are second to none. Knowing that the public is the best judge, it has been our aim to produce an article which is absolutely pure and nutritious and the result has been that a case of Norfolk Golden Ale is regarded as a household requisite in the best clubs of New England."

About its IPA, Habich said it was made with "unequaled brilliancy." As for the porter, it said it "is recommended by all leading physicians as extremely beneficial to the human system." The brewery also said, "We have succeeded in brewing a porter the qualities of which cannot be exceeded."

J.K. Souther and Son, also known as the Burton Brewery, was located at 919 Heath Street, which is now home of the Bromley-Heath Housing complex. It was started by J.K. Souther and brewed such beers as Burton Ale, Bull's Head and Special Porter. In a brewery poster from 1877, the Burton Brewery described itself as an "Ale & Porter Brewery."

The brewery was started by Joaquin K. Souther, who had previously worked at the Van Nostrand brewery. When founded in 1870, the brewery was originally known as J.K. Souther, but it later added "and son" when his son, Clarence Souther, joined the company.

Although the brewery never brewed beer after Prohibition, it survived by bottling the iconic New England soft drink Moxie, which was being made in Lowell, Massachusetts, beginning in 1884.

The Star Brewing Company, located at 69 Shirley Street and 197 Norfolk Avenue in Roxbury, was founded in 1896 and was one of the few independent breweries to survive while the other breweries joined the consortium. Not only did the brewery survive Prohibition, but it also they reopened and brewed beer through 1952.

The brewery had a capacity of 100,000 barrels of beer. Star brewed numerous beers, including the 1896 Ale, Bowdoin Ale, JayJay Ale, Murphy's Ale, Murphy's Beer, Prize Beer, Star Banner Ale, Star Beer, Star Stock Ale and Sullivan's Ale. Also, according to *Beer New England*, "The brewery was a pioneer in the development of sparking ale. It may well also have been, as the century turned, the only brewery in the world with a garden in its brew house. Arthur P. Fegert, Star's brewmaster, felt plants would contribute to a feeling of cleanliness and pure air, that working would be more pleasurable; and that better beer would be the end result."

Two other breweries, the Hub Brewing Company and Continental Brewing Company (also known as Frey & King), did not survive long. The Continental Brewery was founded in 1877. Continental was ahead of its time for many breweries, using a state-of-the-art De La Vergne refrigeration unit and having electric lights throughout its brewery. According to Beer New England, the Continental Brewery marked a "food beer," called King's Bohemian, which was "specially brewed to contain a large amount of malt extract while, with only a small amount of alcohol." It also brewed another beer called King's Culmbacher, which it touted as being aged and "sent out only after it's at least one year old."

The Hub Brewing Company, one of the shortest-running breweries ever, opened in 1898 but closed about four years later. At the same time as Hanley & Casey, both Hub and Continental joined the Massachusetts Breweries Companies and were all closed in the early 1900s.

In a 1903 advertisement in *Modern Brewery Magazine*, the Hub brewery was advertised as being for sale. The ad said the brewery was designed for lager and had the capacity to brew 100,000 barrels of beer a year. The ad described the brewery as being a "handsome, substantial building of bricks with granite trim, concrete, steel and iron with complete modern equipment."

It was an "excellent chance to establish a paying and growing business," the ad said. According to Beer New England, the brewery never sold and closed for good.

Along with Hanley and Casey and Continental Brewery, another brewery, McCormick Brewery (founded in 1885 by James McCormick), all stood at the present location of the Mission Hill Housing Development. McCormick Brewing Company's most popular beer was the Red Label Ale, which came in a large, wine-sized bottle. It also brewed a stock and India pale ale. Another well-known beer was McCormick's Fenway Ale, which was brewed in the late 1890s.

The brewery quoted Dr. James F. Babcock, the state assayer, in its advertisements, saying the beer was good for people and "well calculated to compete with foreign ales," according to Beer New England.

Another Boston brewery, recently discovered to have existed by Reiskind, was the Waldberg Brewing Company, which was founded around 1896 by George Lauzendoerfer in Jamaica Plain. The lager brewery was sold to G.E. Cole in 1898. When the brewery first opened, it had a capacity of 5,500 barrels of beer. Cole increased that capacity to 25,000 barrels. Along with beer, the Waldberg Brewing Company also produced malt extract.

When all of the breweries closed in Boston, it was bad for the city, Reiskind said. He said he doesn't have numbers but noted that a large number of both Irish and German immigrants made a good living working at these breweries "It was a pretty big industry," he said. "We didn't have steel and we didn't have farming (in Boston). We had brewing. It was pretty much all we had."

A TEMPERANCE MOVEMENT IS BORN IN BEANTOWN

Boston had hundreds of taverns, and more and more breweries were being built. Things were good for the brewing industry and beer and ale drinkers during the 1800s.

But not everyone was happy about this. Alcohol, some believed, should not be imbibed, particularly the hard alcohol that many favored. The drunkards, they believed, were a drain on society.

In 1826, a group of Boston-area ministers founded the American Temperance Society, one of the first anti-alcohol groups in all of the United States that spread nationally. The group quickly grew to 170,000 members and 2,220 local chapters throughout the country.

In Massachusetts, the society members helped bring about various periods of prohibition, and they were the forebearers of the Volstead Act, the federal law that prohibited the sale and manufacturing of alcohol that virtually killed the United States brewing industry in 1920.

Originally called the American Society for the Promotion of Temperance, it was founded by preacher Lyman Beecher, along with Dr. Justin Edwards, who was also a reverend in a Boston church.

As a group, it was "an organization that vowed to close down the nation's four thousand distilleries," according to John M. Dunn's 2010 book, *Prohibition*. The group members, at least at first, did not preach for everyone to give up alcohol (although they did believe that everyone should give up hard liquor), but instead, they worked to keep those who did not drink from starting to drink.

Edwards, who worked as the group's secretary, wrote, "A society is formed, not for suppression of intemperance, but for the promotion of temperance," according to 2003's *Alcohol and Temperance in Modern History: An International Encyclopedia*. Edwards believed that if all "temperate men could be induced to continue temperate, all drunkards would soon die, and the land would soon be eased of an overwhelming burden."

In 1836, Edwards penned a pamphlet that was distributed throughout the Bay State called the "Letter to the Friends of Temperance in Massachusetts."

The "Letter," deals heavily with what he called "ardent spirit" and said it was "never necessary" and was "positively injurious." However, Edwards also took a swipe at those who believed beer was safe and not something that should be looked down upon, claiming that the breweries purposely used water that could make people sick.

Edwards wrote:

A bloated, red-faced beer drinker, came to a friend of mine, and wished to put his name to the pledge of total abstinence from the use of distilled liquor. My friend, perceiving his habits, told him he had better put his name to the pledge of abstinence from the use of all intoxicating liquor for said he, "do you know what filthy water they often make use of in brewing?" "O yes," said he, "I have been in a brewery three years myself. I know all about it. And don't you know, sir, that the more filthy the water, the better the beer?" My friend answered, "No." "Oh yes," said he, "that is always the case. In — where I lived, the brewers, in drawing their water from the river, were very careful to have their pipes come down into the river just at the place which received the drainings from the horse stables. And there is no such beer in the world, as they make." He, too, thought that the drainings from the horse stables and filthy ponds were all removed, or purified, by the fermentation, but he was grossly mistaken. And so are all persons, if they think that foul and hurtful ingredients are all removed by fermentations.

At meetings, the American Temperance Society originally asked members to sign a pledge not to drink "ardent spirit." Members who were totally dry were marked with a "T" next to their names to stand for "total abstinence." According to Dennis Nishi's 2003 *Prohibition*, "The word 'teetotaler' derives from this now antiquated temperance term."

Boston's literary magazine *North American Review* supported the efforts of the American Temperance Society in an 1833 article, which said:

Alcohol falsely fills voids in life. At social meetings, we pledge with it. When we are dejected, we resort to it. When we are fatigued, we consume it believing it restores strength. Alcohol is often given to the sick as a medicine. We must temper our zeal for the consumption of alcohol due to these falsehoods.

To the leaders of the temperance societies: Whoever resolves the problem of alcohol misuse, under the auspices of justice, reason, and religion, would render a service to mankind, of which words cannot describe the value.

Massachusetts passed its first type of prohibition in 1838 when it banned the sale of hard liquors in batches smaller than fifteen gallons, according to Joan Johnson Lewis, a faculty member of the Humanist Institute. The amount was considered too large and too expensive for the poor to buy, so the measure was seen as a way to prevent them from drinking.

"The fifteen gallon law was plainly discriminatory and undemocratic," according to historian Andrew Baker's article "The Temperance Issue in the Election of 1840: Massachusetts."

"It was intended to prevent the sale of hard liquor at retail over the bar in taverns," he continued. "Poorer men were cut off almost completely from liquor, whereas the wealthier who could buy in large quantities, and drink at home, were not affected at all. The law did not limit beer and cider sales, but its discriminatory nature displeased any of the moderate temperance advocates, as well, of course, the anti-temperance forces."

In the 1839 election, Governor Edward Everett, a Whig, was facing Democrat Marcus Morton. Although the Whigs had passed the original Prohibition law, they tried to use hard cider as being on the same level as the "common man," Baker wrote. Morton won the election.

"Although temperance was undoubtedly a secondary issue in the election of 1840 except for a few fanatics on both sides, it did probably affect the campaigning of the moderates on both sides," said Baker.

The law was repealed in 1840, but the state did allow a local option, and more than one hundred communities in the state had local prohibition.

There were other periods of prohibition, including one from 1852 through 1868, which prevented the sale of liquor for purposes other than manufacturing and medical purposes. The other prohibition was brief, from 1868 to 1875. Prohibition did not seem to affect breweries in Boston, which continued to brew beer during these periods.

However, there were temperance movements across the entire United States, and brewers were concerned that they, like spirits and taverns, would soon be the targets. Many of the temperance groups were run by women,

and the national trade group the American Brewers Association, headed by Henry A. Rueter, owner of the Rueter & Alley Brewing Company, in Boston, fought efforts to allow women to vote.

"When woman has the ballot, she will vote solid for prohibition," was the official stance of the organization, according to Daniel Okrent's 2010 book, *Last Call: The Rise and Fall of Prohibition*.

Along with fighting women's suffrage, the group took a formal resolution, calling the temperance movement "fanatical," and said it would oppose any candidate "of whatever party in any election, who is in anyway disposed toward the total abstinence charge."

The American Brewers Association spent millions fighting women's suffrage and those who were pro-Prohibition, often spreading misinformation and lies and using borderline-illegal tactics to support their beliefs.

In the end, Okrent wrote, it backfired.

"The brewers' tactics had been self-defeating almost to the point of idiocy," he wrote. "The more they fought female suffrage, the more they guaranteed the antipathy of millions of American women, a large segment of whom might otherwise have been opposed to, or at least neutral on Prohibition."

One of those women who worked toward alcohol abstention was Mary Hanchet Hunt, who became one of the most powerful women in the prohibition movement, according to Dr. David J. Hanson, professor emeritus at the State University of New York.

Hunt, of Boston, was the leader of the Women's Christian Temperance Union's Department of Scientific Temperance Instruction. As part of her duties, she was "to ensure passage of laws mandating that text books teach every school child a curriculum promoting complete abstinence for everyone and mandatory prohibition," Hanson wrote in an essay. Hunt became so popular that she gained veto power over any textbook that she did not approve of.

By 1901, more than twenty-two million schoolchildren in the United States were exposed to Hunt's approved anti-alcohol "education," Hanson wrote. "The WCTU was perhaps the most influential lobby ever to shape what was taught in public schools."

Some who opposed Hunt argued that she was profiting from the reforms, and she signed over to charity all of the royalties on the physiology textbooks that she sold. The charity was the Scientific Temperance Association, of which she, her pastor and a few friends were the only members.

The Department of Scientific Temperance Instruction used "science" for propaganda fliers it distributed throughout the country. The fliers cited medical science, with titles such as "Child Death Rate Higher in Drinking

Families" and "Alcohol Impairs Muscle Work." Among the "facts" that Hunt's Department of Scientific Temperance Instruction promoted as truth were "the majority of beer drinkers die from dropsy," alcohol "turns the blood to water" and "a man who never drinks will get well, where a drinking man would surely die," Hanson wrote.

"The association used its funds to support the operations of the national headquarters of the WCTU's Department of Scientific Temperance Instruction, a large house in Boston that was also Hunt's residence," stated Hanson.

Another Bostonian, Anna Adams Gordon, rose through the ranks of the Women's Christian Temperance Union. She originally was an assistant to the group's president, Frances Willard, but eventually became president herself. As president of the group, she helped convince President Woodrow Wilson to toughen rules about using foodstuffs in alcohol, according to *Alcohol and Temperance in Modern History: an International Encyclopedia.*

The Women's Christian Temperance Union still exists today, and it is still fighting alcohol, tobacco and illegal drug use.

Although the American Temperance Society was one of the early temperance groups, it wasn't the first time temperance was an issue in Massachusetts. As far back at the 1650s, the Massachusetts government was worried about the amount its citizens were drinking, historian Gregg Smith wrote in his 2000 article "Brewing in Colonial America."

"The government was alarmed by intemperance among its citizens," he wrote. "However, complete abstinence was never one of their goals; they just wanted to keep things under control. It was one of the new social drinking rituals which gave them no end of grief, the drinking of toasts."

The government put in place a law to limit toasts, but it was ignored.

"It wasn't until 1712 when the 'Act Against Intemperance, Immorality and Prophaneness, and for Reformation of Manners,' put some teeth into enforcement," Smith wrote. The law led to several people being arrested at an incident in 1714, but the law was later done away with.

Prior to the American Temperance Society rising to a national level, another smaller group formed in Boston in 1813 called the Massachusetts Society for the Suppression of Intemperance. According to the National Commission of Marijuana and Drug Abuse, the Massachusetts Society of Intemperance fought more than alcohol. It was also against "kindred vices, profaneness and gambling." Several of the founders of the American Temperance Society were connected to the Massachusetts Society of Intemperance but left the group to form their own group.

CHAPTER 4

CHANNELING A
FOUNDING FATHER

SAMUEL ADAMS IS HERE

Jim Koch seemed to have the perfect life in the early 1980s. He was married with two young children, living in the beautiful Boston suburb of Newton. He was making $250,000 a year working as a manufacturing consultant.

But his family wasn't happy. Jim constantly traveled, spending weeks away from home at a time. Koch was missing seeing his son and daughter grow up, and his wife wanted things to change. She wanted her husband home more, but Koch was not convinced until one of the rare nights he was actually at home.

"My wife said to my daughter, 'Meghan, Daddy wants to talk to you,'" recalled Koch. "She walked right by me, went over and picked up the telephone and said, 'Hi Daddy.' That was heartbreaking."

That was in 1981. Today, Koch is the president of the largest craft brewery in the United States, the Boston Beer Company, housed in the former Haffenreffer Brewery in Jamaica Plain. Makers of the ubiquitous Samuel Adams Boston Lager, Boston Beer Company's beers bearing the Samuel Adams name are now available in all fifty states and several foreign countries, and the company brews more than two million barrels of beer a year.

But it wasn't a guarantee that Koch was going to leave his high-priced job for brewing. His father was against this move.

Brewing was in Koch's blood—his grandfather Louis was the brewmaster at a brewery in Ohio, and Koch's father, Charles, followed in Louis's footsteps, brewing throughout the 1940s and 1950s.

A small sign for the largest craft brewer in the country. *Photo courtesy of the Boston Beer Company.*

However, the two men had very different experiences. Louis Koch was one of the first technically trained brewers in the United States and was brewing beer during the heyday of American brewing, in areas dominated by Germans, where the brewmaster was one of the most important people in the community. He was one of the most respected people in his community.

"My grandfather was a brewmaster and that was a big deal," said Koch. "He once told me the owner of a brewery made an appointment to see the brewmaster. That was how important a brewmaster was."

By the time Charles Koch became a brewer, however, the industry had changed. Prohibition had killed hundreds of breweries, and giant breweries were systematically killing the smaller regional breweries that had once been part of a local community's identity. Now, instead of all beer being brewed locally, it was being brewed in just a few spots in the country, and brewing jobs were at a premium.

Living in Cincinnati, a young Jim Koch did not know the problems his father was having. Charles Koch constantly changed jobs as brewery after brewery closed. In his last few years as a brewer, Charles could not find a job close to home. He would travel, living in a motel during the week and then coming home on Wednesday to visit his young family before going back to the motel.

"He eventually got out of the brewing business in the 1950s," said Koch. "He told me the last six months that he only made $500. I didn't realize at the time we didn't have a lot of money. My mother worked at a local bakery, and we always had cake. I was the envy of all the other kids because I always had cake. I didn't know it was because we were getting it for free."

Because of his own experiences, Charles did not want his son to follow in his footsteps. And Jim Koch never had any desire or expectations to work in the beer industry. Instead, Jim Koch traveled to Boston, where he attended the prestigious Harvard University, earning both an MBA and a JD, with brewing not even being a grain of an idea in his head.

After living for a few years in Seattle, Washington ("The Boston Beer Company came really close to being the Seattle Beer Company," he said), Koch returned to Boston to work for the Boston Management Group, a prestigious consulting firm. For the firm, he traveled around the country, working with large manufacturers, helping them become more efficient at what they were doing, earning high wages and easily supporting his young family.

When most people left the Boston Management Group, they typically left to join one of their largest clients. Jim Koch did not want that. He saw how big manufacturers worked and realized they did not maximize the talent they had working for them. He wanted his own business where he could do things the way he thought they should be done. He wanted to be able to maximize everything to its fullest.

Beer wasn't his first idea. Koch's wife worked in the medical field. He thought about opening a series of standalone medical facilities where those who use emergency rooms for routine medical care could go to lessen the pressure on hospitals. He also considered a company that dealt with cutting-edge (for the time) technology dealing with phone lines.

However, on a trip to San Francisco with his father, Jim Koch tried Anchor Steam, a locally brewed beer produced by the Anchor Brewing Company, owned by Fritz Maytag. The beer was different than anything Jim Koch ever had. It was flavorful, and it wasn't yellow and clear, like pretty much every other beer being brewed at the time. It was different, and it was good.

"That was an interesting beer," said Koch. "It piqued my interest. Beer really captured my imagination. It was the right business."

Despite misgivings, Charles Koch worked with his young son, helping Jim Koch begin homebrewing in his kitchen, trying to develop a recipe. One of those recipes was one created by Louis Koch in the late 1800s or early 1900s. It was a full-flavored German-style lager, with more hops, all barley malt and significantly more flavor than any of the American lagers that dominated

the market and nearly killed the regional brewing industry. Jim had found his new business. And that beer, brewed with his father in his kitchen based on his brewmaster grandfather's recipe, became the basis for Boston Lager.

Koch began studying all of his father's brewing books and pamphlets and began working toward opening his own brewery. But it was not a quick process. Craft brewing, a term that did not even exist in the mid-1980s, was still in its early stages. Many states did not have rules governing breweries. Brewing equipment designed for small breweries was nearly nonexistent, and breweries were left trying to use repurposed equipment from old soda manufacturers or dairy farms. That often led to a lack of consistent beer or, even worse, beers that were infected by bacteria, making them nearly undrinkable.

"Quality was paramount," said Koch. "It's small and cute to do it all by hand—that's great if the beer is great. Brewers in 1984 didn't always brew good batches. Some were good batches and some were bad batches.

"The beer had to be great every time. Not nine out of ten times. Not 95 percent of the time. It had to be great every time. If you look at the brewery survival rate, it wasn't good. It wasn't a mystery to me. I was a manufacturing guy. I always thought quality came first. My dad tried some of these beers and he looked at me and said, 'Jim, you can't make bad beer.'"

Charles Koch then came up with an idea to find an existing brewery that could brew the Samuel Adams Boston Lager. Contract brewing was not a novel idea, as other brewing companies had done it. It also caused a lot of strong reactions in the new brewing community. Brewers who built their breweries from the ground up looked at contract brewers as taking a shortcut, taking the easy way out without putting the sweat and tears into the process.

Despite the fact that many existing brewers looked down on contract brewing, the world-renowned beer expert Michael Jackson, known as the "Beer Hunter," defended Koch and Boston Beer Company. In an interview in the December 1996 edition of *Yankee Brew News*, a Massachusetts-based free newspaper, Jackson praised the company. He said it made good beers, such as the Cream Stout and Boston Lager, and he believed that West Coast brewers "were miffed that an upstart from the east could attain such success without even owning a major brewing facility," the article said. Jackson said Koch put what people used to call microbrews "on the map" in the United States.

For Jim Koch and his partners (fellow Harvard grads Lorenzo Lamadrid and Harry Rubin), it made sense. Get the beer brewed exactly how it should be and dedicate the small amount of money they had to selling their beer.

Boston Beer Company founder Jim Koch stands with some of the first cases of Boston Lager that were boxed. *Photo courtesy of the Boston Beer Company.*

Koch visited the regional breweries that still existed. Many of the breweries had much more capacity than he and his partners were using, so they would welcome the influx of extra beer to brew and extra money they would make. However, Koch had a hard time finding a brewery that could handle brewing the Boston Lager in the correct method. The Boston Lager was brewed using decoction mashing, a method not often used in the 1980s (or today for that matter). The beer was also dry-hopped, which was nearly a lost art. Koch settled on the Pittsburgh Brewing Company, an old-time lager brewery that had no problem with decoction mashing.

Before going to market, Koch contacted Dr. Joe Owades, the man who helped create light beer and many other brewing innovations. Owades ("the Yoda of craft brewing," Koch said) lived in Boston, and Koch wanted him to help with the brewery. Koch couldn't afford his consulting rates, so to get Owades on board, Koch offered him 2 percent in the company, and Owades came on board and helped tweak the final recipe. What started

as a business partnership ended as a close friendship, with Koch giving the eulogy at Owades's funeral in 2005.

Now Koch and the Boston Beer Company had a brewery to brew the beer, and they had a recipe they were pleased with. The team settled on the name Samuel Adams Boston Lager to honor a Boston Patriot and to connect with the city. Now, they had to figure out how to sell the beer. Koch was in manufacturing. He didn't sell things.

For help, Koch reached out to Rhonda Kallman. Kallman was an administrative assistant at the Boston Consulting Group who also worked part time at night at various bars as a bartender and waitress.

"He asked me to help him," said Kallman. "He knew about beer, and I knew about bars. It was just the two of us selling the beer. Our focus was going up and down the streets and asking every bar to carry us. We didn't know what we didn't know."

Even though Koch had left the company, Koch maintained his office at the Boston Consulting Group on State Street. So, in March 1985, Koch left his office with samples of Boston Lager and walked to the first bar he saw, the Dockside Restaurant & Bar, a quick jaunt down State Street, and made the pitch.

"I didn't want to do that. I had never sold anything. I had to try to convince people that something they've never heard of, something that tasted like nothing they had tried before, was something they should buy. I was scared shitless," said Koch. "I left that day and I promised I'd sell my beer to one bar. I started talking to the man behind the bar, and he was looking at me like I had two heads. It turned out he was a bar back. The manager came over—I think he thought I was with immigration or the IRS. I let him try the beer, and God love him, he said, 'Yeah, I'll put the beer in.'

"I left and realized that I didn't ask how much he wanted. I was too embarrassed to call him right away, so I called the next day and they bought five cases," Koch said. "He wanted me to come in and do a promo. I didn't have shirts or anything to give away. I just went in and talked to people, and they bought the beer. It worked, and that's how we still do it today."

It wasn't that easy all the time. Koch and Kallman were going it alone. The pair went bar to bar trying to sell the Boston Lager. The problems were many. The idea of a local beer was foreign in Boston—there had not been a brewery in the city since the Haffenreffer Brewery closed its doors in 1964. The beer tasted different than beers like Budweiser, Miller and Coors, which—except for a few bars that carried the British Bass Ale—was all that anyone ever had, and people didn't know what to make of it. And, finally, even from the bar owners who were familiar with the idea of

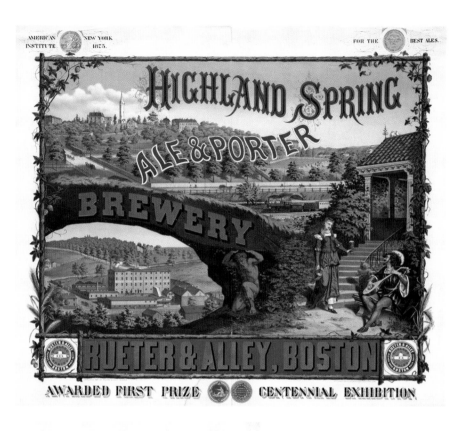

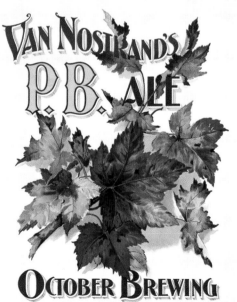

Above: The Highland Spring Brewery was an award-winning brewery that was killed off due to Prohibition. *Photo courtesy of the Boston Public Library.*

Left: An ad for Van Nostrand's incredibly popular P.B. Ale. *Photo courtesy of the Boston Public Library.*

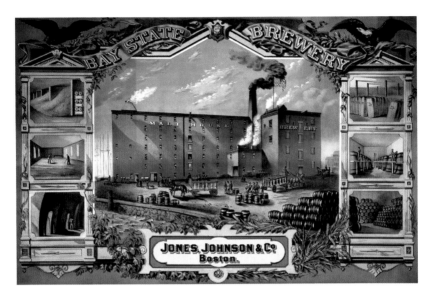

An ad displaying all of the different aspects of brewing at the Jones Johnson & Co. brewery. *Photo courtesy of the Boston Public Library.*

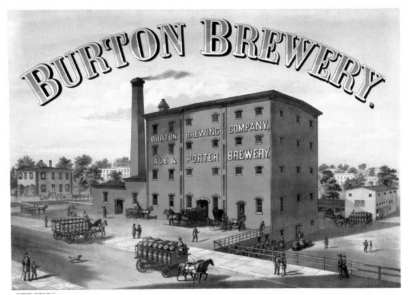

The Burton Brewery was one of the larger breweries in Boston. *Photo courtesy of the Boston Public Library.*

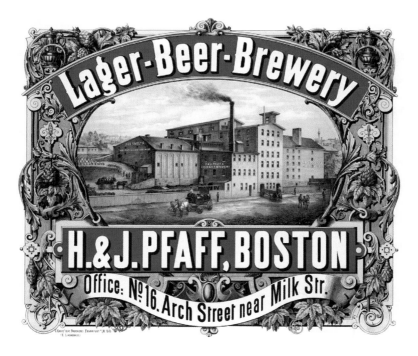

A portrait of the popular H&J Pfaff Brewery in Boston. *Photo courtesy of the Boston Public Library.*

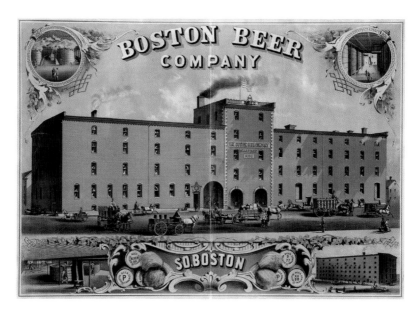

The original Boston Beer Company has no connection to the modern-day company of the same name. *Photo courtesy of the Boston Public Library.*

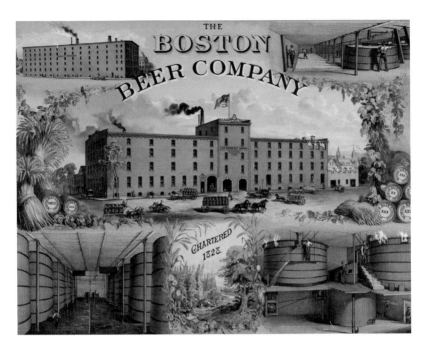

Another drawing of the Boston Beer Company, this one showing several of the internal areas of the large brewery. *Photo courtesy of the Boston Public Library.*

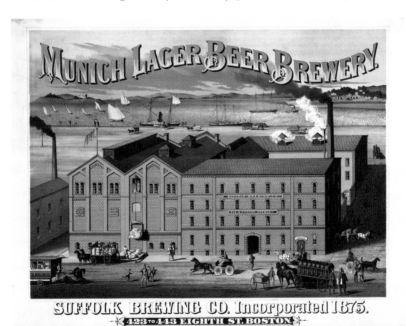

The Suffolk Brewing Company was also known as the Munich Lager Brewery. *Photo courtesy of the Boston Public Library.*

Left: An advertisement for American Beer Company's Lager Beer. *Photo courtesy of the Boston Public Library.*

Below: The Frank Jones Brewery was one of the largest in all of New England, and it expanded to Boston in the late 1800s. *Photo courtesy of the Boston Public Library.*

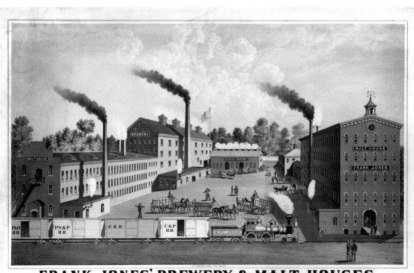

FRANK JONES' BREWERY & MALT HOUSES.
PORTSMOUTH, N.H.
DEPOT 82 & 84 WASHINGTON ST. BOSTON.

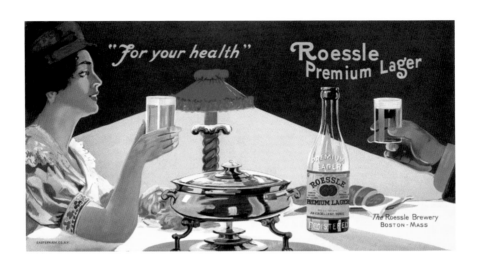

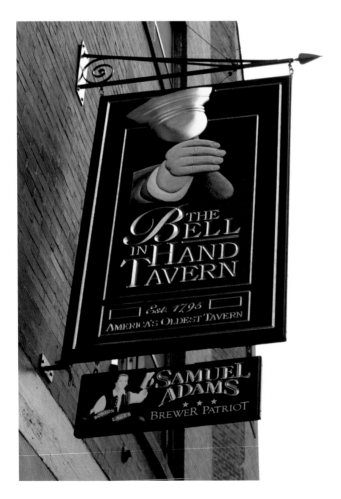

Above: An advertisement for Roessle Lager, touting its health benefits. *Photo courtesy of the Boston Public Library.*

Left: The sign to the entrance of the historic Bell in Hand Tavern. *Photo by Sara Withee.*

The exterior of the present-day Boston Beer Company, located in Jamaica Plain. *Photo courtesy of the Boston Beer Company*.

One of the first things visitors to the Samuel Adams brewery see. *Photo courtesy of the Boston Beer Company*.

Jim Koch, founder, stands in front of barrels of beer in the Samuel Adams barrel room. *Photo courtesy of the Boston Beer Company.*

Jim taking a swim in a dunk tank of beer. *Photo courtesy of the Boston Beer Company.*

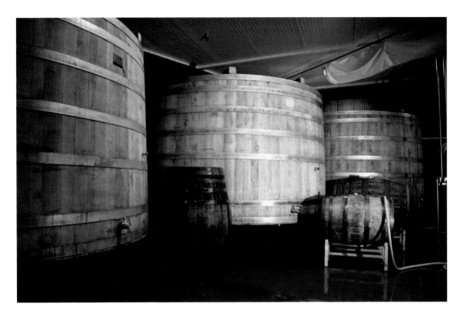

Above: Giant barrels of beer in the Samuel Adams barrel room. *Photo courtesy of the Boston Beer Company.*

Left: Samuel Adams Utopias, the strongest naturally fermented beer in the United States. *Photo courtesy of the Boston Beer Company.*

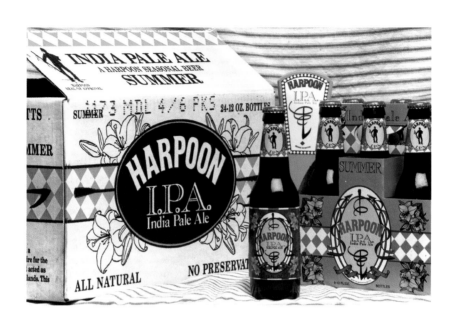

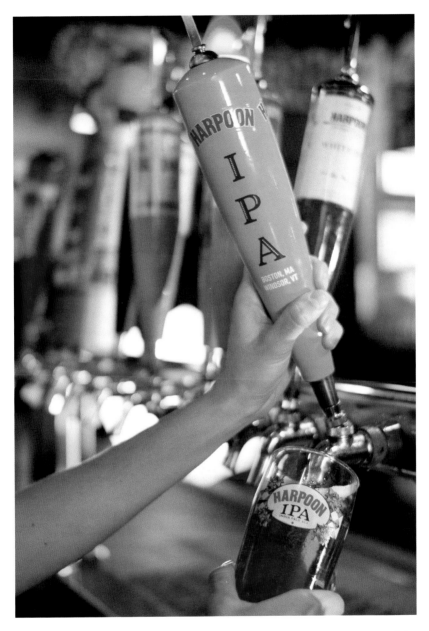

Above: A pint of Harpoon being poured in the Harpoon Beer Hall. *Photo courtesy of the Harpoon Brewery.*

Opposite, top: The Harpoon IPA originally started as a seasonal, as marked on this case. Today, it's Harpoon's top-selling beer. *Photo courtesy of the Harpoon Brewery.*

Opposite, bottom: The Harpoon UFO was the first East Coast version of a German hefeweizen. *Photo courtesy of the Harpoon Brewery.*

Harpoon founders Rich Doyle and Dan Kenary. *Photo courtesy of Harpoon Brewery.*

Harpoon Helps has raised thousands of dollars for New England food banks. *Photo courtesy of Harpoon Brewery.*

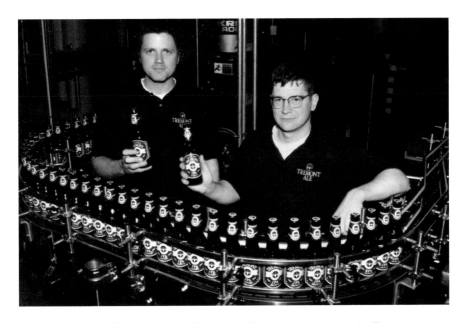

Tremont founders, Chris Lohring (left) and Alex Reveliotty, monitoring the Tremont bottling line. *Photo courtesy of Chris Lohring.*

The Trillium Brewing Company was the first brewery to open in Boston since Tremont went out of business. *Photo courtesy of Trillium.*

The custom-made tap handles at Trillium. *Photo courtesy of Trillium.*

Trillium's tasting room. *Photo courtesy of Trillium.*

Some of Trillium's beers are brewed in barrels such as these. *Photo courtesy of Trillium.*

Others are brewed in traditional steel tanks. *Photo courtesy of Trillium.*

A glass of Trillium's namesake beer, a delicious farmhouse ale. *Photo courtesy of Trillium.*

Trillium glasses lined up next to growlers in the Trillium tasting room. *Photo courtesy of Trillium.*

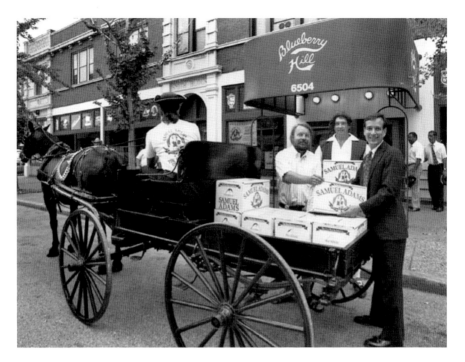

Boston Lager being delivered by a horse-drawn carriage. *Photo courtesy of the Boston Beer Company.*

microbrews, Koch found there was a prejudice against lager. Nearly every other microbrewed beer at the time was an ale.

Koch and Kallman ran into bar owners who hated the beer, others who liked it but didn't think it would sell and even those who wouldn't give it a chance. Despite those early problems, Koch said he never doubted Boston Beer Company would be a success.

"It was difficult," said Koch. "There was an occasional person who drank it, liked it and wanted to have it for their customers. It was maybe one out of ten. I never had one of those moments of doubt or fear. We had virtually no overhead. We didn't have an office, and we didn't even have phones. We did all our business using payphones. We didn't spend money on anything but making the beer and selling the beer. I was never worried, and it was easier than I thought it would be."

The average order was about $39.50 for two loose cases of twelve-ounce bottles of Boston Lager. As the beer began popping up in more bars, more people began requesting it at other bars. More and more bars started putting in orders.

Because no one had heard of Samuel Adams, no local distributor would take on the beer, so Kallman said it was up to her and Koch to deliver all of the beer.

"I'd load up my little van in the morning and drive all over delivering it," she said. "Then I'd bring my heels and change in the bars and do promos. That was all we did for the first nine months. It was pretty tough. We were selling Samuel Adams Boston Lager that cost five dollars more (per case) than Heineken, and it was Boston's beer, but brewed in Pittsburgh."

Six weeks after selling its first beer, Boston Beer Company was invited to the Great American Beer Fest in Colorado, a large beer festival that awards medals for the best beers in various categories. It won a gold medal.

"Boston Beer being crowned America's best beer really showed us what we were going to be," Kallman said.

Samuel Adams began growing quickly. It was making waves in the beer world, and there was a backlash among established breweries, but Koch didn't care. He was getting beer brewed exactly how he thought it should be into the hands of consumers. Although he did not own the brewery, Koch was at the Pittsburgh brewery, overseeing the brewing of each batch, staying at the local Red Roof Inn for twenty-nine dollars a night, just to get up to start brewing the following day at 5:00 a.m.

Although the business was growing, Koch leaving the Boston Management Group and sticking closer to home did not save his marriage. Koch and his wife got divorced. She kept the family's large Newton home while Koch kept Boston Beer Company. Koch moved into a tiny Waltham apartment so he could still be close to both Boston and his children. He lived there for several years.

Samuel Adams, along with another contract brewer, Pete's Brewing Company, brewers of Pete's Wicked Ale, soon became one of the largest craft beer producers in the United States. The fact that two of the largest beer producers were contract brewers did not sit well with a lot of others brewers. Some established brewers looked at contract brewing as almost cheating, historian Maureen Ogle wrote in her 2006 book, *Ambitious Brew*.

"I think contract brewers should represent themselves as just what they are," said Ken Grossman, founder of Sierra Nevada, "brokers who are having their beers manufactured by another brewer. I don't think they should put themselves over as brewers."

But Samuel Adams and Koch were defended by beer journalist Fred Eckhardt, according to an article he wrote, quoted in *Ambitious Brew*. Eckhardt wrote, "We need contract brewers. Without them, the craft brewing industry

would still be small time." He also said that Koch "had done more for craft beer and craft brewing than almost anyone else."

Although contract brewing was going well, Koch wanted to open up his own brewery in Boston. He settled on the old Haffenreffer Brewery in Jamaica Plain. All fourteen of the original brewery's buildings still existed. And to Jim, the idea of opening his own brewery in the last brewery to close in the city after Prohibition was appealing.

"I thought, 'This is where I want to brew my beer.' This is what I thought of as a brewery—a red brick building in the middle of a city," he said.

In 1985, one of the largest buildings that Koch planned to house his brewery, owned by the Jamaica Plain Neighborhood Development Corporation, was in bad shape. Almost all of the windows were broken. The roof had holes, and trees and plants were growing through walls. It was a high-crime area. But Koch decided that was the home of his future brewery. Koch leased the building and began the repairs, and by 1987, he planned on converting it and moving all of Boston Beer Company's brewing endeavors to Boston. The Boston Beer Company originally leased eight hundred square feet of the building for one dollar a year.

Koch worked to design a brewery that could brew up to 250,000 to 300,000 barrels a year, which would have been the largest craft brewer in the United States by a large margin. He spent $2 million on the design and began purchasing equipment. He had $11 million to build the brewery. Excitedly, he began soliciting bids, ready to become a fully brick-and-mortar brewery.

Then Koch's plans smacked into a wall. Many bids came in, but the lowest was $15 million, $4 million more than he had available to build his dream brewery. Koch was crushed. The Boston Beer Company was at a crossroads, and Koch did not know what to do.

"To get the other $4 million, I would have to risk giving up control of the company. Did I really want to risk that?" he said. "My father said, 'Jim, don't risk what you have to get what you don't need.' I'd be risking everything, and if it didn't work, I was done."

Koch had hired Andy Bernadette, a graduate of the University of California–Davis brewing program, as his brewmaster. Bernadette had a background in manufacturing, and he worked to convince Koch to scale down his plans and let him use his manufacturing experience to build a smaller brewery, one that would come in within the budget and wouldnt risk the company's future.

Koch agreed and contacted his old friend Bill Newman of the recently closed Albany Beer Company and leased his equipment. Ninety days after

the beginning of the process, Samuel Adams began brewing its first beer in Jamaica Plain in 1987.

The Boston Lager was still being brewed in Pittsburgh. Lagers take longer to brew than ales and take more tank space because you need to let the beers age before packaging them. The new Jamaica Plain brewery was small and did not have space to brew and store the lagers.

So in 1988, Boston Beer Company decided to join the other craft breweries around the country and introduced a new beer, the Boston Ale, to take advantage of how quickly the ales were ready for sale compared to lagers. This allowed the Boston Lager to maintain its quality but also allowed the company to introduce more new beers to help expand. All of the early beers brewed in Jamaica Plain were ales. Other early beer from Samuel Adams included the Double Bock (which still exists) and Light Ship, a light lager introduced in 1987 but no longer available.

Samuel Adams continued to grow, and its chief competitor in the early days was Pete's Brewing Company, another contract brewer. After several different investments by those who did not have a passion for beer, Pete's was purchased by the Gambrinus Company in 1998 and then discontinued in 2011, the fate that Koch was afraid of when he decided not to get the last $4 million to fund the original plan for the Jamaica Plain brewery.

"Pete's is an example of what I was worried about," said Koch. "The people behind it didn't have the passionate commitment. Pete (Slosberg, founder of Pete's) did, but the others were there for the money."

Business was steadily increasing throughout the late 1980s and early 1990s, but Koch wanted to do more. Most U.S. craft brewers brewed re-creations of European styles, as did the Boston Beer Company. Koch wanted to make a thoroughly American beer, and he wanted to make something memorable. He wanted to brew the strongest beer in the world. In the early 1990s, that title went to Samiclaus, an Austrian lager that came in at a hefty 14 percent alcohol by volume (ABV). Koch used the 1952 essay by Perry Miller, "Errand into the Wilderness," as his inspiration to top Samiclaus.

"No one thought you could get a beer over 14 percent. I said that's not true. Boston was founded as an 'Errand into the Wilderness.' The founding of the Massachusetts Bay Colony was an 'Errand into the Wilderness.' That's what kept Boston exciting and vibrant. Boston isn't a center of just tradition. It's a center of innovation. That was the motivation behind this beer 'Errand into Wilderness.' I always liked pushing boundaries. To me, the most fun I have is doing something never done before."

Barrels of Triple Bock still exist at the Jamaica Plain brewery. A small amount is used in each batch of the Utopias. *Photo courtesy of the Boston Beer Company.*

Koch had to do something different to get yeast to survive in higher alcohol than it ever had before. The brewers came up with the idea of forced mutation, basically brewing a beer as strong as possible, harvesting the surviving yeast and repeatedly repitching it until they got a yeast that could survive at higher and higher alcohol levels. Koch then decided to do something foreign to brewing at the time: aging the beer in wooden barrels previously used for bourbon and other liquors. Koch lays claim to being the first brewer in the modern era—with a possible exception for an unknown Scottish brewery—to barrel age a beer, a practice that is common today.

The final beer was the Triple Bock, a 19 percent ABV bock on steroids. Consumer reactions were mixed. Some people liked it, while others described it as tasting like soy sauce. It was clear that people had never tasted anything like it, and some just did not like it. But for Koch, it was something he enjoyed, both to drink and to brew. It also drew a lot of media attention. In an interview, Koch coined the term "extreme beer" to describe the Triple Bock, inspired by the growing popularity of extreme sports, full of athletes who did not care about marketing or TV contracts but just wanted to have fun.

Boston Beer Company brewed several vintages of the Triple Bock and then brewed Millennium in 2000 before finally introducing the strongest naturally fermented beer in the world, the Utopias, first released in 2002. The Utopias is a beer like no other. It is not carbonated. It is brewed with several different types of yeast, including Champagne yeast, and maple syrup to add fermentable sugar. Next, several base versions of the beer are aged in different types of oak barrels for various lengths of time, and then the beers are all blended, along with some of the original Triple Bock, still in barrels since 1993, into a finished version of Utopias. The Utopias has reached a high of 29 percent ABV in 2012, the tenth anniversary of the initial release, and it typically retails for $160 to $200 a bottle. It still sells out each year.

The early to the late 1990s was a roller coaster for craft breweries. Craft beer producers—such as Boston Beer Company; Sierra Nevada Brewing Company in Chico, California; and Boulder Beer Company in Colorado—began drawing media attention. Home brewers began getting excited about hearing these stories of mostly men brewing batches of beer in their kitchens that eventually became the beers they now sell in stores. They saw a chance to turn the hobby they love into a career.

Those were the people who got into brewing for the right reasons. Then there were those who saw craft beer as a chance to make a quick buck, and Koch said investors who had no interest in beer and how it tasted began to get involved in the industry. The market was flooded with a lot of bad to mediocre craft beer.

The growth in craft beer also began to attract the attention of the big brewers, such as Anheuser-Busch, Miller and Coors. Koch appeared on the popular primetime news show *Dateline NBC* in 1998 for an interview on craft beer. The show turned into an indictment on craft beer, highlighting the fact that Boston Lager was not brewed in Boston. Many viewed it as a hatchet job, set up by big-time NBC sponsor Anheuser-Busch.

Either way, in the late 1990s, the bubble burst, and a large number of the breweries that were founded in the 1990s closed. Samuel Adams, as well as Boston's other brewery at the time, Harpoon Brewery, survived, while many did not.

"It was the venture capitalists," said Koch. "Ultimately, that was why it crashed."

In 2000, Boston Beer Company said goodbye to Kallman, who decided she needed a change.

"I felt myself going further and further from consumption, where I really took pride in my work, to the business side," she said. "I felt like I had given Sam Adams fifteen years and I had nothing left to give."

Kallman started her own contract brewery called New Century Brewing Company, where she produced a craft light beer. She later added Moonshot, a caffeinated beer. She was forced to stop having it brewed after it got caught up in the Four Loko controversy that saw the federal Food and Drug Administration ban caffeine-based alcoholic beverages. Now Kallman is working to open Boston Harbor Distillery, a whiskey distillery in Boston.

Kallman looks back at her days with the Boston Beer Company fondly.

"It was the American dream," she said. "Jim Koch and I were the best team in the industry. Together, we changed the industry. Jim always believed it would happen. To me, I…it took me some time. It continues to amaze me at the rate of growth they have. Samuel Adams has been around for thirty years, and they're still going strong, and I'm proud to say that I helped."

The Boston Beer Company has had its share of controversies throughout its decades in business. It was involved in a trademark dispute with brewpub chain Boston Beer Works over the Beer Works name. The case ended up going all the way to federal appeals court, where the Boston Beer Company lost. (More details of the case can be found in the Boston Beer Works chapter.)

In August 2002, Koch got caught in a totally different type of controversy. According to an August 31, 2003 *Bloomberg Business Week* article, Koch took part in a promotion on a New York radio show called "Sex for Sam," where participants were offered a trip to Boston if they had sex in "the riskiest places." A couple from Virginia got caught having sex in New York's Saint Patrick's Cathedral in an effort to win the prize. The fallout included the jocks losing their jobs and Koch having to issue a statement, which said, "We were not in control of the program, and it was never our intention to be part of a radio station promotion that crossed the line."

Then in October 2007, the Boston Beer Company sent a cease-and-desist letter to a Portland, Oregon radio station that had purchased the domain names "samadamsformayor.com" and "mayorsamadams.com" in honor of Sam Adams, who was running for mayor in Portland, according to an October *Wall Street Journal* article. In the letter, Boston Beer Company said consumers could confuse Sam Adams the mayoral candidate with the Samuel Adams beer.

In 2011, Boston Beer Company filed suit against Anchor Brewing Company of San Francisco and a former Boston Beer Company employee who had a non-compete agreement about working at another brewery, according to a September article in the *Boston Business Journal*. At the time of this book's publishing, the suit was still pending.

Then, in the summer of 2013, Boston Beer Company raised the ire of patriotic and religious beer fans alike when it omitted a portion of the Declaration of Independence from an advertisement, according to a July 2013 article by CBS-Boston.

"All men are created equal, that they are endowed with certain unalienable rights: life, liberty and the pursuit of happiness," the script for the ad reads, while the actual Declaration of Independence says, "…that all men are created equal, that they are endowed by their Creator with certain unalienable Rights, that among these are Life, Liberty and the pursuit of Happiness."

Boston Beer Company issued a statement, saying, "The Beer Institute Advertising Code says, 'Beer advertising and marketing materials should not include religion or religious themes.' We agree with that and try to adhere to these guidelines. While we understand your objection to the omission of the phrase 'by our creator' in other circumstances (after all, they occur in the Declaration of Independence which Samuel Adams signed and helped author) we believe it would be outside our industry guidelines to invoke those religious words in a beer commercial," the statement said.

Despite those controversies, Boston Beer Company is still going strong.

Today, Samuel Adams is one of the most prolific breweries in the world. The brewery typically releases upward of fifty or sixty different beers a year, and several new beers are introduced each year. The Boston Lager is still the most popular Samuel Adams beer, but several other beers are quite popular. Along with the Boston Lager, the Boston Beer Company brews fourteen year-round beers, including the Boston Ale, Sam Light, Noble Pils, Cherry Wheat, Irish Red, the Cream Stout and the Black Lager.

The Boston Beer Company also brews several IPAs, a style of beer that Koch had no interest in brewing, despite its popularity. India pale ales, or IPAs, were created in England. The popular story of the origination was that the normal British pale ales and other beers would not survive the long trip from England to those English citizens who had settled in India during colonization. Hops, a leafy flower that is a preservative, was added in higher amounts in these beers to survive the long trip from England to India. People loved the beer, as hops can add many different

flavors—earthy to tropical, fruity or piney and many others in between. People were clamoring for them.

Since the 1990s, IPAs have been the darling of the craft beer world. The goal of Samuel Adams was to always release the best beer in its particular style, and Koch said he did not feel like it had anything to add to the IPA category. He and the brewers then came up with the idea of Latitude 48, a beer brewed with five different hops—Noble hops from Germany, British hops and American hops all grown on the forty-eighth longitude.

Since Latitude 48's release in 2010, Samuel Adams has brewed numerous different IPAs. It even released the Samuel Adams Latitude 48 Deconstructed Pack, which featured the Latitude 48, as well as five different versions, each brewed with one of the five hops—Hallertau Mittelfrueh from Germany, East Kent Goldings from England and Ahtanum, Simcoe and Zeus from the United States—used to brew the beer. The idea was to show what flavors each hops add to the beer.

Samuel Adams also brews the Whitewater IPA, a hybrid Belgian witbier and IPA, and the Rebel IPA, a West Coast IPA introduced in late 2013. Other variations that are only occasional releases include the Grumpy Monk (Belgian IPA), Dark Depths (Baltic porter/IPA hybrid) and Juniper IPA, a winter IPA brewed with juniper. Samuel Adams even released the Double Agent IPL, or India pale lager, in 2013.

Samuel Adams also has a popular seasonal program. Along with its Summer Ale, Octoberfest Lager and Winter Lager, it brews several different season-specific beers, such as the Porch Rocker in the summer and Old Fezziwig during the winter. Other seasonal releases include Cold Snap (a witbier for spring), Harvest Pumpkin Ale (fall) and White Christmas (a witbier for winter).

Other beers that appear in various seasonal variety packs but are not necessarily season specific include the Belgian Session Ale, Blueberry Hill Lager, Little White Rye, Ruby Mild and the Cherry Chocolate Bock. The company also has some seasonal higher alcohol beers released only in bombers, such as the Fat Jack (imperial pumpkin ale for the fall) and Merry Maker (a gingerbread stout for the winter).

The Boston Beer Company also does the Imperial Series, a group of beers higher in alcohol than the normal Samuel Adams lineup. These beers are available in four-packs rather than six-packs. Along with the Double Bock, the series includes the Imperial Stout, Imperial White and Wee Heavy.

Most of Samuel Adams' beers are still brewed outside of Boston but now are brewed at facilities owned by the Boston Beer Company, one in

Brewing vessels inside the Boston Beer Company. *Photo courtesy of the Boston Beer Company.*

Cincinnati and another in Pennsylvania. The Jamaica Plain brewery is more of a research and development location, with brewers trying new beers, often only available in the Samuel Adams tasting room during tours and special events, as well as at local bars. The location also has a small ten-gallon nano-brewery for even more experimental beers.

Some beer is brewed and bottled for the market in Boston. The Jamaica Plain brewery is home to the Samuel Adams Barrel Room, a room filled with a large collection of barrels previously used for different types of liquors. Some of these barrels still have some of the 1993 Triple Bock aging, and many of them hold ales that will be blended into future versions of the Utopias.

It is also home to a special creation: the Kosmic Mother Funk—an intentionally sour, bacteria-infected ale that is not bottled or sold. Instead, it's the base beer in all of Samuel Adams Barrel Room Collection, a series of barrel-aged beers brewed in Boston and released in limited amounts. The Barrel Room Collection includes the New World Triple, Stonybrook Red, Tetravis, American Kriek and Thirteenth Hour.

Koch has not forgotten his homebrewing start. Each year, Boston Beer Company holds the Longshot competition. It is a nationwide homebrewing competition where home brewers submit their best recipes, and a panel of experts select two beers (along with an employee winner) to be sold in a special Longshot six-pack.

In 2012, Samuel Adams introduced the Boston 26.2 Brew. It is a special beer brewed in honor of the historic Boston Marathon. The beer is draft only and is available in bars on or near the marathon route.

The Jamaica Plain brewery has also heard its shares of wedding bells. In 2012 and 2013, Brewlywed was released. Brewlywed is a Belgian "wedding beer" and is only released at the brewery for one day. Couples who dress in wedding attire get first crack at the limited release. Several people have actually come to the brewery with marriage license in hand and a justice of the peace at their side. With Koch acting as best man, several couples have taken the most sacred of vows surrounded by Samuel Adams beers, exchanging their first kiss as a married couple in front of the Boston Beer Company brewing team.

In 2013, Boston Beer Company crossed a line Koch never thought would happen—it began canning its Boston Lager, as well as some seasonals. The company spent millions of dollars developing a can that Koch was happy with. It came up with a can with a wider mouth and a different lip that Koch said let his Boston Lager taste the same as if it was poured into a glass.

The company has also shown that it respects those who came before it. In the 1970s, New Albion Brewing Company in California was the first craft brewery to start a business from nothing. The brewery lasted for several years but went out of business in the early 1980s.

Koch was familiar with the beer, and when he saw that the trademark expired in the 1990s, Koch took it over to prevent someone else from trying to capitalize on the name. Every few years, Boston Beer Company would release a beer to a select few draft accounts and call it New Albion Ale to keep the trademark active, but it had nothing to do with the original beer.

That all changed in late 2012, when a Samuel Adams employee in Texas called Koch. She had entered her local homebrewing competition and met Jack McAuliffe, who told her about his brewery, the New Albion Brewing Company. Koch, excited, had her get the contact information for McAuliffe.

In 2013, Koch and McAuliffe partnered to recreate the original New Albion Ale. They even had access to the original yeast that had been kept alive at the University of California–Davis labs. The beer was released

to a lot of fanfare, with a portion of the proceeds going to McAuliffe. After the release of the New Albion Ale, Koch gave the trademark back to McAuliffe, whose daughter, Rene DeLuca, has announced that she will start New Albion again, brewing the beer at the Mendocino Brewing Company in California.

The Boston Beer Company also joined together with Alan Newman, founder of the Magic Hat Brewing Company in Burlington, Vermont, to create Alchemy & Science. Alchemy & Science allows Newman to come up with various ideas, funded by the Boston Beer Company, to create something new. Some of these endeavors include the creation of the Traveler's Beer Company, which brews several types of shandys; purchasing the Just Beer name from the Buzzard's Bay Brewing Company in Westport, Massachusetts; and creating a lineup of good, solid—but not complicated—beers. Alchemy & Science also purchased the Coney Island brand of lagers from the Schmaltz Brewing Company. All of these are under the umbrella of the Boston Beer Company.

Also part of the company is Angry Orchard, a cider company that began in 2012. It was the Boston Beer Company's second foray into cider. It had introduced a moderately successful line of the ciders in 1997 called Hardcore.

Today, the Boston Beer Company is one of the two largest American-owned breweries in the country (it flip-flops with Yuengling in Pennsylvania constantly). It brews approximately two million barrels of beer a year, much different than Koch's original expectations.

"My business plan was to get to five thousand barrels, have eight employees within five years and making $1 million in sales," he said. "I used to teach mountaineering, and I told Rhonda one day that we're at the base of the mountain, but we're starting to climb. No one climbs a mountain to get to the middle. Let's get to the top. We want to be the largest and best well-made beer in the United States. I always used to say that we wanted to sell more beer in the U.S. than Heineken. We're still halfway there. We're getting there."

Despite being in his sixties, married a second time with a teenage daughter and having enough money to live comfortably for the rest of his life, Koch said he has no plans to leave the Boston Beer Company.

"Why would I want to retire? Life is not about being comfortable. Being comfortable never mattered to me. If it was about money, I could have left twenty years ago. I'd get bored. I get excited about cool new things, by pushing boundaries and creating new beers."

Koch said he is confident that the Boston Beer Company will continue, even as more breweries continue to enter the market. The reason, he said, is that Boston Beer still follows the core beliefs it has had since it began.

"I learned early on you can make good beer and be successful or you can accept less. We don't accept less," he said. "Nothing leaves this brewery unless it's a pleasure to drink. It cannot fail that test. I don't want to make a beer that isn't a pleasure to drink. The secret to our success was Sam Adams made world-class beer every batch, and we continue to do that now, and we will continue to do that in the future."

HARPOON BREWERY BRINGS BREWING BACK TO THE HUB

If you look in the state books to see who has Massachusetts Brewers License #1, you will find the name of the largest craft brewery in New England: the Mass. Bay Brewing Company,, or as it is better known, the Harpoon Brewery.

In 1964, the last brewery in Boston, Haffenrefer, closed. From that time on until 1987, no breweries were producing beer in the city of Boston, until three Harvard University students—Rich Doyle, Dan Kenary and George Ligeti—decided to change that.

"The need was tremendously great," said Doyle, chief executive officer of Harpoon. "As a beer drinker, the selection was very sparse. You had light lager. Starting a brewery was a no brainer; I didn't have to take a class to know there was a need for that."

Doyle and Kenary were friends at Harvard, where they spent several nights out and about sharing beers at local watering holes. After college, the pair went their separate ways. Kenary went to the University of Chicago, where he earned his MBA before taking a job in the banking industry. Doyle worked on Wall Street for a couple years before returning to Harvard University to earn an MBA of his own.

While in New York, Doyle had a chance to try some of the early craft beer that had just started making its way to the East Coast, such as Anchor Steam and Sierra Nevada Pale Ale. A trip out west gave Doyle an opportunity to try even more beer—beer that had flavor and was virtually nonexistent in Boston. He also made trips to Europe and Asia, exposing himself to more beer.

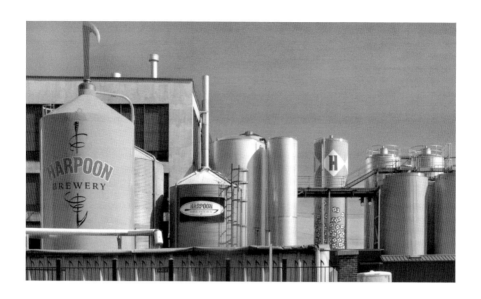

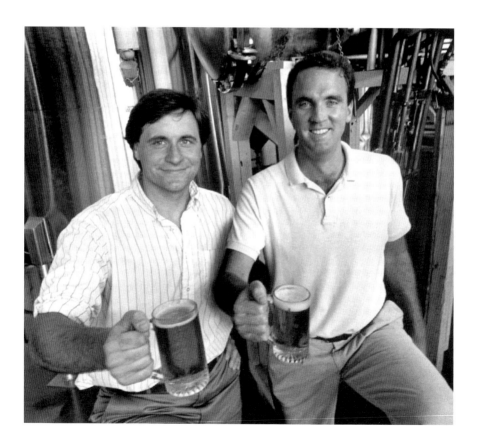

In a 1988 interview with Will Anderson for his book *Beer New England*, Rich Doyle spoke about some of his early inspiration for starting a brewery.

"I spent a significant time in Europe and Southeast Asia, in the South Pacific, and I thought, 'There are great beers there. Why is it necessary to have to go, in some cases, to a third-world or second-world country to get a good-tasting beer?' That didn't make a lot of sense," Doyle said.

When he returned to the United States, Doyle returned to Harvard to earn his MBA. As part of a project, he had to develop a business plan. He and his roommate developed the plan to start their own brewery. Doyle knew the plan was solid, but his roommate was not interested in actually bringing the plan to reality.

Doyle wanted to go forward with the plan. He knew Ligeti because they were in the same grouping at Harvard University. Ligeti had a degree in engineering. Doyle also contacted his old friend Kenary, who was now a vice-president at the First National Bank of Chicago.

Kenary's job was good, but he was bored. He had traveled to Europe and loved the beer drinking experiences there, as well as the flavorful beer options that he had compared to those back home in the United States. He wanted a change, and when Doyle offered him a chance to open up his own brewery, it was something that intrigued him.

"He [Doyle] started telling me about opening an independent brewery," said Kenary. "I was too immature to be a banker. The one thing I learned from being a banker is I didn't want to be banker for the rest of my life. I was twenty-five and single. I was always intrigued with starting my own business. I visited Europe and I loved the pub culture and I loved the beer. It's ridiculous that the beer here was so bad. We would frequently lament the shitty choices we had. You either had light lager or lighter lager. If you were lucky, you could get a Bass Ale or a Killians. I think what was unusual about us opening a brewery was that we weren't home brewers. We were just frustrated consumers. I didn't even know about home brewing until after we opened."

Opposite, top: The Harpoon Brewery is the largest craft brewery in Boston and is in the Seaport District in Boston. *Photo courtesy of the Harpoon Brewery.*

Opposite, bottom: Founders Rich Doyle (left) and Dan Kenary enjoy a Harpoon Ale in the 1980s. *Photo courtesy of the Harpoon Brewery.*

Although the trio looked at different options for where to put the brewery, including Kenary's hometown of Worcester, they never really considered anywhere other than in Boston. They were looking for a five-thousand- to ten-thousand-square-foot facility that could handle holding the large and heavy brewing equipment. There were only three locations they could find in Boston that fit the bill, Doyle said. One of those locations was in an old shipbuilding warehouse factory in the Seaport District. In 1986, the Commonwealth Brewing Company was incorporated, and Mass. Bay Brewing (better known as Harpoon) got Brewery License #1 in 1987.

"The whole element was, we wanted to be a brewery in Boston," Doyle said.

In an Associated Press article from April 1987, both Doyle and Kenary said they were going to rely on the fact that it was Boston's only local beer to help its sales.

"I've been drinking and reading about beer for a long time," said Doyle. "We want to prove you can brew locally."

Kenary said, "Most Americans don't know what fresh beer tastes like."

In June of that year, along with original brewer Russ Heissner, Harpoon Ale, a draft-only beer, was released for the first time. The first bars to carry the beer were Doyle's in Jamaica Plain and Sevens in Beacon Hill.

"People were very supportive," said Doyle. "They liked our story. They liked our effort. They liked the beer. And they liked that we were in Boston."

Heissner moved from California to Boston to become the head brewer at Harpoon, spurning a job opportunity at Anheuser-Busch after completing the University of California–Davis brewing program. He was the one tasked with creating the first beer, the Harpoon Ale. At first, he brewed several versions in his apartment, and then he brewed his first batch at the brewery. It did not go well.

"According to the brewing log I kept, the first batch of Harpoon was made on April 24, 1987," Heissner said in 2012 in his blog, Everything I Know About Business I Learned in a Brewery.

"We threw it away. It took 7 more batches before #'s 8 and 9 on May 25th became Harpoon Ale, and we proceeded to keg beer for commercial sale. The rest of that year is a blur. I stopped my brewery log after batch #15. Too busy to take notes; too busy do much of anything but make beer."

Although they had beers in some bars, it was a lot of pressure early on, Kenary said. To start the brewery, the trio had to borrow much of the money from a group of thirty-five friends and family members because banks wouldn't loan them any money.

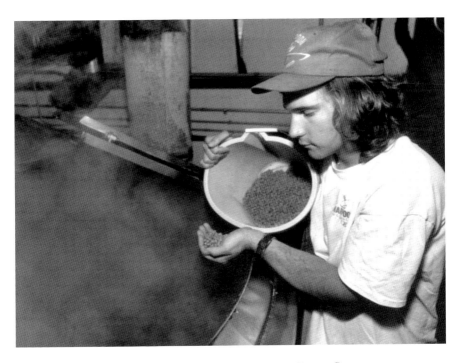

A brewer adding hops to the brew kettle. *Photo courtesy of the Harpoon Brewery.*

"That's when it got really serious," said Kenary. "We took that much money from people so you really feel the pressure to succeed."

The three men paid themselves only $18,000 a year, barely enough to live on and significantly less than they could earn in other industries with their MBAs. Kenary and Doyle were the original salesmen, splitting the city in half, going bar to bar trying to sell the Harpoon Ale. Their top competition was Samuel Adams Boston Lager, a beer ubiquitous with Boston but not brewed there; Killians Irish Red; and Bass Ale.

"It was a real crapshoot," said Kenary. "Depending where you were, 2 percent of the people understood. People didn't know what to do with our beer. When we first started, we targeted fifty accounts. Back in the '80s, most bars maybe had three to six tap handles."

About six or seven months after opening, Harpoon purchased its first bottling line, allowing it to now have bottles of its Harpoon Ale.

The early days were not easy, Heissner wrote.

"We had no idea what we were really getting ourselves into. I often wonder if, we were able to foresee how difficult the road ahead would be, would we

make the same choices? When thinking of new ideas, most folks get stuck in the concept stage, and never risk do anything further. Rich, George, and Dan took that risk. They conceived a great idea. They wrote a plan. They communicated their vision and raised equity. They dedicated themselves towards the birth of brewery, and ultimately, a successful operating business."

In the early days, despite running a young business, the founders and Heissner would have fun. On his blog, Heissner remember Ligeti organizing "Russ-Fest," where the founders took him on a "cultural introduction" to Boston, including trips to the Combat Zone and candle-pin bowling while drinking out of brown paper bags.

In December 1988, Harpoon introduced its second beer, the Winter Warmer. It was a seasonal beer, something that was not common in 1988. It was also the first of what became a full seasonal program, which Doyle said was the first in the United States. The brewery continued to expand, adding brewing capacity to brew more beer. In its first year, Harpoon brewed 2,300 barrels. In 2013, it brewed more than 200,000 barrels.

Despite the consistent growth, things weren't easy and the brewery's success was not a sure thing.

"We didn't break even for five years," said Doyle. "It was touch and go for those five years. If it wasn't for perseverance and commitment, we wouldn't have survived. It was in August 1992 when we broke even, when he had a really good month. We were going to be in the black. I never…I always kind of looked at it as a year-to-year thing."

Doyle, Heissner wrote on his blog, was reflective about how important Harpoon could be to many people.

"I remember a time over beers when Rich and I had an opportunity to reflect on what we were doing, and Rich said something to the effect that we weren't just building a brewery, that we were building a business where people, and ultimately their families, would derive a way to make a living," Heissner, who now works in the biofuel industry, wrote. "And that he felt that weight upon his shoulders. He also said something that stuck with me: that what we were doing had 'good karma.'"

Harpoon began having another issue with its beer—bottling. The draft beer was always good, but bottling was an issue—"a nightmare," Kenary said. "We had plenty of issues with our bottled product."

The beers tasted fine when fresh, but some bottles would be fine for months, while others would begin to deteriorate within a few weeks. Knowing that the market was finicky and not wanting consumers to buy the beer that was not up to the standards they believed it should be, things needed to change.

The solution was to work with F.X. Matt, a family brewery in Utica, New York, that did contract brewing. Harpoon's bottling operation was moved to F.X. Matt, while Harpoon continued to produce all of its own draft product.

"When we stopped bottling ourselves and Matt started bottling for us, that was huge," Kenary said.

Around the same time, Harpoon had hit a financial wall. It wasn't dipping, but it was not growing. A difficult decision was made—Ligeti and Kenary left Harpoon, while Doyle remained by himself. Kenary remained local, working as the chief financial officer for a biopharmacy company and continuing to help Harpoon, sitting on the board of directors, but Ligeti moved to Seattle and never returned to working at the brewery. He is now an executive in an architectural engineering firm in Florida.

In 1993, Harpoon made a decision that helped make it the brewery it is today—Doyle and new head brewer Tod Mott introduced a new summer seasonal beer: the Harpoon IPA. India pale ales are the number-one craft beer style in the world today, but in 1993, only a few West Coast breweries tried the British style of ale that was brewed with more hops that could add citrusy and piney flavors. The style was nonexistent on the East Coast.

Although Doyle and Mott came up with the idea together, Mott was in charge of developing the IPA. Mott hadn't been brewing all that long—only about five years. His wife had bought him a home brewing kit as a gift while he was earning his master's degree in ceramics from Boston University in 1988. He fell in love with the process—a combination of artistry and science that reminded him of ceramics. He began entering home brewing competitions and was "cleaning up," Mott said, winning most of the ones he entered. Mott was hooked.

"It's really, really interesting that brewing is so similar to ceramics," said Mott. "The process was very similar. It's artisanal and it's science at the same time. There's something about art and science combined that attracted me to it."

Mott got his professional start at Vermont's Catamount Brewing Company, where he did a four-month-long internship. After his time there, he said he knew he needed brewing to be part of his life for years to come.

In June 1991, Mott was brought on at Harpoon to fill in for the head brewer, who injured his hand in an accident. After four months, Mott was named the permanent head brewer.

"He [the head brewer] realized I was more involved and into the product than he ever was going to be and he left," Mott said.

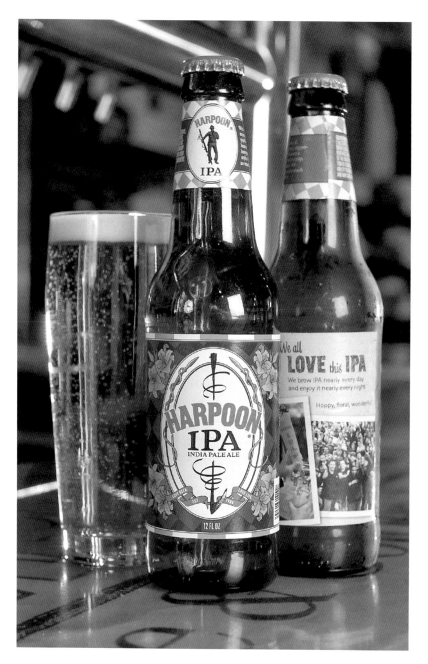

The Harpoon IPA, originally introduced as a seasonal, is Harpoon's best seller today. *Photo courtesy of the Harpoon Brewery.*

The first beer Mott created was the Harpoon Stout in 1992, which was inspired by the Sierra Nevada Stout. Massachusetts beer drinkers were used to Guinness, the popular creamy Irish stout, and weren't ready for the hoppy version Harpoon released.

"People didn't like it at first," he said. "It was the hops."

In 1993, Mott and Doyle began discussing brewing a summer seasonal. Mott thought it was time to revisit hops and suggested an IPA to Doyle, which intrigued him. IPAs were once a popular style of beer in England but, except for a few versions on the West Coast, weren't common.

"I designed this IPA, and I swear to God, it took off," said Mott. "It's been the number-one seller for Harpoon ever since, and they haven't looked back. The next thing you knew, by 1995 and 1996, every brewery was brewing an IPA. I feel I had a certain credibility because I brewed the first IPA on the East Coast."

Mott left Harpoon in 1993 because he wanted more control over the beers he brewed.

"I wanted to go smaller, and Harpoon was on its way to getting bigger," he said. "I didn't have control when the beers went out; Rich did, even if I didn't think they were ready."

He worked at a series of brewpubs in Boston before moving to the Portsmouth Brewery in New Hampshire. There, he helped put the Portsmouth Brewery on the radar of beer lovers worldwide, brewing the world-renowned Kate the Great Russian Imperial Stout, a beer that was released once a year and attracted people from around the world. It earned the coveted top rating on the popular website Beer Advocate. Mott has now started his own brewery in Maine with his son.

Although started as a summer seasonal, Doyle quickly realized he had a monster of a beer on his hands, and it quickly went into year-round production. The Harpoon Summer Ale, a Kolsh, replaced the IPA as the summer seasonal. Along with a now-thriving seasonal program that included the Harpoon Summer Ale and the Harpoon Oktoberfest, Harpoon began growing from a small local brewery to a brewery known around the country.

"Things began to stabilize with the introduction of our IPA," said Kenary, who returned in 1996 as Harpoon's chief financial officer. "In 1994–95, we had great marketing, and we grew from the hardcore five employees to fifteen people and we were struggling to keep up with the growth."

Harpoon decided to expand, but it wanted to do it intelligently and not overextend itself. The mid- to late 1990s were not kind to a lot of craft breweries. Many were making bad beer, but even those that were making

good beer expanded before they were ready and eventually closed. Harpoon wanted to expand, but it wanted to do it in a smart way. Doyle and Kenary expanded slowly, buying larger brewing vessels from the Virginia Beer Company that was going out of business, while selling the old equipment to a start-up in California that later went out of business.

In 2000, Harpoon purchased a second brewery, the Catamount Brewing Company in Vermont, which had fallen prey to overexpansion. That increased Harpoon's brewing capacity by twenty-five thousand barrels and allowed it to open new markets without putting too much stress on the Boston brewery. It was this slow, smart growth that allowed it to not only survive the bad times but also to flourish and grow.

"People over-expanded, and if you over purchase, you're guessing your business that the sales will catch up, and if they don't, the businesses go under," said Doyle. "We brew great beers, and we're financially conservative. We haven't had our eyes on things that are bigger than the whole of our parts. We're in twenty-six states, and we haven't added a state in almost four years (2009). We're always taking the opportunities as they come without extending ourselves. The thing about the beer business is you have to be good at so many things. It's art and science, and it's business. You have to be able to brew good beer, and you have to be able to sell the beer and manage all the people. You have to manage the supply side, marketing, labeling, and a lot of people couldn't do that."

Kenary added, "No way were we ever going to put anything at risk. Because of what we went through and the struggles we had in the late 1980s and early '90s, we knew the importance to run a profitable business. If you don't focus on money enough, if you don't make enough money to pay your bills, you're not going to last. When the bad times hit in the 1990s, we always made money. Maybe a little less than the previous year, but we always made money. We've always been financially frugal. For example, to this day, we don't buy pens. You go to banks, you go to hotels, and they always have free pens, so we figured, why buy pens? Now we have piles of pens around that people bring in from their trips."

The 2000s saw tremendous growth for the Harpoon Brewery. It continued to add new beers—such as the Harpoon UFO, which stands for Unfiltered Offering. Like the Harpoon IPA, the Harpoon UFO was a first on the East Coast. Widmer Brothers in Oregon brewed a popular wheat beer, but the Harpoon UFO was the first East Coast hefeweizen. Since then, the brewery has added many different UFOs to the lineup, including a Belgian pale ale, a Belgian white, a raspberry hefeweizen and even a pumpkin wheat beer.

Just like the UFO, Harpoon has also added numerous different IPAs to the lineup. The Rich & Dan's Rye IPA was originally brewed as a twenty-fifth anniversary beer, but it became so popular that it became a year-round beer. Harpoon also brews a white IPA, a black IPA and a popular imperial IPA called Leviathan.

Late in 2013, Doyle and Kenary rebranded the Harpoon IPA as a New England IPA in an effort to make it stand out from the much hoppier West Coast IPAs that Doyle said accentuate hops and bitterness, rather than balance.

"When we started brewing Harpoon IPA twenty years ago, there weren't other IPAs," said Doyle. "The category has grown up around us, [and] it is now the most popular category in all of craft beer making and beer drinking. And I think what's happening is there is such a broad spectrum of IPAs, in terms of alcohol content, bitterness and aroma. And you have people that say they don't want to try an IPA and we get discouraged because what we have is [a] well-balanced IPA that sort of harmonizes all of the ingredients. We look at Harpoon IPA as a New England–style IPA, something that harmonizes the ingredients instead of having one dominate. The reason we do that is it helps the customer understand what they are going to get. It helps to define the customer expectation."

Other year-round beers include the Boston Irish Stout, Harpoon Dark and Harpoon Ale. Along with the Octoberfest and Winter Warmer, the other seasonals include the Summer, the Long Thaw and the Chocolate Stout.

In 2004, Harpoon began to shed some its early year-round beers that were underperforming. But Doyle said he still wanted to keep things fun for its brewers. So Harpoon introduced the 100 Barrel Series.

"We were cutting beers, but I said, 'Let's find a way to entertain ourselves,'" said Doyle. "That's when we created the 100 Barrel Series. The 100 Barrel beers were going to the extremes."

Brewers were allowed to create various beers that were different from the norm. The catch was only one hundred barrels, or 3,100 gallons, of the beer would be produced, and the beers would be available in twenty-two-ounce bottles, known as bombers, instead of the normal twelve-ounce bottles that Harpoon had always used. Except in limited cases, once the beer was gone, it was gone forever. Sometimes the beer is just a creation of one of Harpoon's brewers' imaginations. Sometimes, they're inspired by the yearly beer culture trip employees take to Europe. Other times, they are collaborations. The only similarity is the size of the batch and the fact that they are unique, and for the most part, once they're gone, they're gone for good.

As of December 2013, Harpoon has done forty-eight different 100 Barrel Series beers. Some of the notable ones included the Triticus, the tenth beer, a wheat wine brewed with Jason and Todd Alstrom from Beer Advocate; the Firth of Forth Ale, the twenty-second beer, a dark scotch ale brewed with American hops; the Catamount Maple Wheat Ale, the twenty-sixth beer, brewed in honor of the Catamount Brewery, made with real Vermont maple syrup; and beer number thirty, the Island Creek Oyster Stout made with real Island Creek Oysters.

As a fun experience for employees, Doyle and Kenary hold an employee homebrew contest. The winning beer becomes a 100 Barrel beer.

In the 2000s, the craft beer world began to be dominated by high-alcohol, high-octane beers—double IPAs, imperial stouts, barleywines and Belgian quads. Harpoon, except for a couple 100 Barrel Series beers, had nothing to compete in that category. The solution was the Leviathan Series. Each beer in the series was around 10 percent alcohol by volume (ABV) and was available in four-packs instead of the normal six-packs. The beers included the Imperial IPA, Imperial Red, Barleywine and the Quad.

Today, the Leviathan series is no more. The Leviathan IPA is a year-round beer, and the others have been renamed and are special releases, such as the Bronze King (barleywine) or the Imperial Pumpkin Stout, available in twenty-two-ounce bombers instead of in twelve-ounce bottles.

In 2009, Harpoon introduced craft cider to its portfolio. Along with the Harpoon Craft Cider, it also makes the Harpoon Honey Cider and the Harpoon Pumpkin Cider. In early 2014, Harpoon announced it was going to introduce a new shandy to the lineup. A shandy is a popular beverage in England and is typically a blend of beer and lemonade.

Harpoon comes up with new beers in a relatively easy manner. It brews a new beer on the small pilot system it has in the Boston brewery, and the new beer is put on tap in the employee break room. Typically, a beer that is good runs out quickly. Since the Beer Hall was opened, the beers are also put on tap there, so the new beers can be crowd sourced just feet from where they are being brewed.

"That's a good way to find out what people really think," Kenary said.

As Harpoon has grown from a small brewery that was known at first just to Boston-area beer drinkers and then to New England beer drinkers before becoming what it is today—one of the largest craft breweries in the country—Harpoon gives back to the communities that host its breweries. In 2001, Harpoon started the Harpoon Helps program, the philanthropic arm of the Harpoon Brewery, supported by both the Boston and Windsor

locations. Between 2001 and 2013, the Harpoon Brewery has donated more than a quarter of a million bottles of beer to various charitable events, as well as nearly forty thousand volunteer hours. Each month, through Harpoon's fan program called Friends of Harpoon, Harpoon Helps sends out missions to the members of the group, seeking helpers at various charity functions. Some of these event missions include sorting food at the Greater Boston Food Bank, participating at American Red Cross blood drives and serving food at a soup kitchen in Portland, Maine. Harpoon Helps also sponsors several charitable 5K races throughout the year, as well as bike rides, including the popular Brewery-to-Brewery Ride, which challenges bikers to ride the 148 miles from the Boston brewery to the Windsor brewery.

In addition, Harpoon brews a special beer to benefit the Harpoon Helps program called the Grateful Harvest Cranberry Ale, an ale perfect to pair with a Thanksgiving meal and made with locally harvested cranberries. For each six-pack of Grateful Harvest purchased, one dollar is donated to a food bank local to where the beer is purchased.

Also, for each pint or growler (sixty-four-ounce bottles) of Grateful Harvest purchased at either the Harpoon Brewery Beer Hall or the Windsor brewery's restaurant, one dollar is donated to various charities. One dollar is donated for every pumpkin pretzel purchased at each location, as well.

"We've raised tons of money with the program, and we facilitate a lot of things with the program," Kenary said.

In February 2013, Doyle and Kenary realized a dream they hoped would come true since the time they started the brewery: building a true European-style beer hall on site at the Seaport brewery.

"We've always wanted to do a beer hall in the traditional way, where people come in and drink beer at long tables and be able to sit there and talk to each other and be social," said Doyle. "I think it does it in a really nice way. We've spent a lot of time and effort on it."

Kenary said, "It's been something we've been thinking about because there really is nothing like it out there. We were inspired by the trips to Europe and we loved the communal nature."

The hall is large, and it has seating for about three hundred people, mostly all at long wooden tables with benches. There is also bar seating. The beer hall also features twenty Harpoon beers and ciders on tap, as well as Harpoon root beer, iced tea and lemonade.

The Harpoon Beer Hall is not a full-scale restaurant. The only food available is giant, freshly baked pretzels made with spent grain left over from

In 2013, Harpoon realized a dream, opening up a European-style beer hall that serves nothing but Harpoon beer and giant pretzels. *Photo courtesy of the Harpoon Brewery.*

the brewing process. There are also several different dipping sauces for the pretzels. The reason there isn't a full menu is that Doyle and Kenary do not want to compete with the local restaurants that have been supporting them from day one. The idea is for someone to come in, have a beer or two and a pretzel before heading to another restaurant in the Seaport District.

The beer hall has a separate area for private functions that can host up to sixty people, as well as caterers so full meals can be served at those events.

What will make the Beer Hall memorable for visitors is a series of catwalks that people will be able to walk on that go above the brewery, so people can see what is going on, no matter how busy the brewers and other employees are.

"The Beer Hall is beer appreciation in a social setting," said Doyle. "We wanted to do something different. Everything we've done is to add to the visitor experience."

Kenary said, "I think the Beer Hall upstairs is a realization of what a Boston brewery could be. It's, in a lot of ways, bringing brewing back to Boston."

To add to the visitors' experience, Harpoon hosts several outdoor beer festivals a year at the brewery, featuring live music from local bands, food

from local restaurants and, of course, beer brewed right on site. The outdoor festivals include the St. Patrick's Day festival and the Octoberfest festival. The events are amazingly popular, with revelers enjoying themselves for hours.

Harpoon also has the Friends of Harpoon program. Harpoon fans can sign up for the program, and they will receive e-mail alerts about beer releases and special Friends of Harpoon events held at the brewery, exclusively for members of the group. They will also get discounts on the outdoor festivals and, on occasion, may even get a special prize in the mail, such as a Harpoon glass.

After being part of a successful brewery for so long, Kenary said he sometimes thinks back in amazement of how things have changed since he and Doyle sat in local pubs as Harvard University undergrads drinking flavorless beers.

"It's really incredible, it really is," he said. "We've been at it for so long, and looking at the numbers we have reached—when we began 100,000 [barrels] was such a big number—it's such a good thing to be part of. When we started, the U.S. was the worst place in the world to be a beer consumer. Now it's one of the best places in the world to be a beer consumer and we're part of that."

As more and more breweries continue to pop up around the state, region and country, Doyle said he hopes people remember the important role Harpoon played in the infancy of craft beer. He also said his goal for the future is to continue making Harpoon the best brewery in the country to visit.

"We started brewing in Boston. No one was doing it before us," said Doyle. "Nobody does events like we do in Boston. Nobody does tours like we do. What is interesting about us is we are trailblazers. Everything we've done, we've done to add to the experience. A lot of people don't get it because they weren't around when we started. A lot of the things people are doing now, we've already been doing it. We want to continue to make the experience something memorable. We have 450,000 people visit our breweries each year. If we can deliver 450,000 great experiences, that would be awesome."

GRAB A PINT BEFORE THE GAME AT BEER WORKS

Today, if you plan on going to a Red Sox game at Fenway Park, expect a madhouse—traffic jams, people walking shoulder-to-shoulder and every single bar and restaurant packed to the gills with pregame revelers.

But in 1991, it wasn't like that. The team wasn't as good. Same-day game tickets were easy to come by, and there were several closed and empty buildings and businesses near the park.

It wasn't the ideal location for brothers Joe and Steve Slesar. The pair wanted to open up a brewpub and settled on a closed and boarded-up Salvation Army building at 61 Brookline Avenue. The Boston Beer Works was born.

"It was a success from the get-go," said Joe Slesar, principal owner of the Beer Works chain, which includes two brewpubs in Boston, as well as locations in Framingham, Hingham, Lowell and Salem.

Joe Slesar moved to Boston from St. Catherines, Ontario, Canada, in 1986 to attend business and law school at Boston University after earning a degree in hospitality from Cornell University in Ithaca, New York. His younger brother, Steve, followed a year later, hoping to attend film school at Boston University after graduating from the University of Rochester (New York) with an English degree.

Beer was an important part of the Slesars life. Steve Slesar said he and his brother were allowed to have an occasional beer as teens while living in Canada, and when he attended college, he was in charge of securing beer for his fraternity.

So when he came to Boston, it wasn't a stretch for Steve Slesar to take a job at the Commonwealth Brewing Company, the only brewpub in Boston at the time. He began as a busboy in August 1987 but became an assistant brewer that winter, where he worked with Tim Morse, who is the director of brewing operations for the Beer Works chain today.

"I eventually came became the head brewer by March of 1988, which was crazy," he said. "I was king of the hill. I had free range. The owner was never there, so I got to do whatever I wanted."

In March 1989, Steve Slesar made the leap to the Harpoon Brewery, where he became an assistant brewer. He later got offered the head brewer's job, but he declined and decided to attend the Siebel Institute, a brewing school in Chicago.

"It was an exciting time to be Harpoon because things were just exploding," he said. "But it was also lonely working there. There's no waitstaff, there are no TVs, no customers. I really liked working at a brewpub."

When he finished, he returned to brewing at the Commonwealth Brewing Company. Joe Slesar also began working at Commonwealth as a paralegal, and Steve Slesar said he always planned on opening up a brewpub of his own. He originally was thinking about Austin, Texas, but later he and Joe Slesar began working with the owners of the Commonwealth Brewing Company about opening a second location. Commonwealth was well known, had a fan base in place and would make a good strategic partner. It even got to the point where the brothers secured a location on Newbury Street. However, the Slesars and the Lee family, who had bought sole ownership of the brewpub, could not work out terms and the deal fell through.

"We decided, 'Why not do it on our own?'" Joe Slesar said.

It was easier to say than actually do. Boston real estate was expensive. The brothers began searching for a storefront they could lease and settled on the Fenway location, which wasn't perfect, but it fit their plans.

"Fenway wasn't the market it is today," said Joe Slesar. "It was previously a Salvation Army warehouse. It was a boarded up concrete space."

Now that they had their location, they needed the money to open up a brewpub. Joe Slesar wrote up a business plan, and the brothers went to more than fifty different banks seeking a loan. They all turned them down because they thought beer was a fad, Joe Slesar said.

"Our parents mortgaged their house to get us some seed money, and a small local bank gave us the rest," he said. "You're under the gun at that point. If you don't succeed, your parents lose their house. That's not a good plan. You have to succeed at that point."

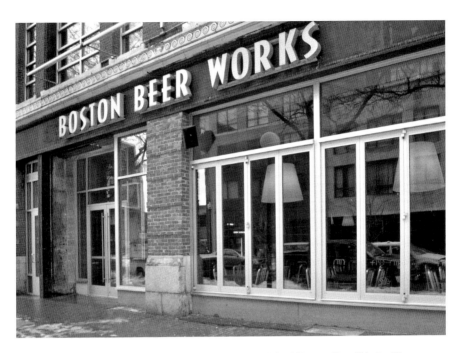

A familiar sight outside Boston Red Sox games, the original Boston Beer Works. *Photo Courtesy of Beer Works.*

Steve Slesar said, "I used to have all fifty-two rejection letters hung up on my walls. We really built the restaurant on the cheap. I had to sell my Jeep to pay for the original TVs."

Steve Slesar was the head brewer, while Joe Slesar ran the business side. A third partner, Marc Kadish, ran the kitchen. Kadish also owned one of the early Boston beer bars, the Sunset Grill & Tap in Allston. The Sunset Grill remains a popular beer destination for beer lovers today.

The first beer Steve brewed was the Boston Red, a staple at all of the Beer Works location to this day. Steve Slesar brewed several test batches of the Irish red ale, and he had many willing taste testers on hand.

"We were testing the beers during construction days and I remember many construction workers walking around drinking our beers," Joe Slesar said.

"I got to do all of the brewing and recipes," said Steve Slesar. "I was young at the time and I wasn't married, so I didn't mind working all of the hours."

Along with the Boston Red, the other beers that were on tap that first week included a Kolsh, a light beer named Bambino, a raspberry ale and the Hercules Strong Ale, which was a barleywine.

In the spring of 1992, the first Boston Beer Works finally opened. It opened two or three days before the first Red Sox home game of the season. Immediately, the place was packed.

"We opened with eight tap lines," said Joe Slesar. "By the end of the first weekend, we only had two beers left because we blew through everything."

The early patrons were more than just sports fans, Steve Slesar said. Then Boston Red Sox general manager Lou Gorman was a frequent visitor. Players such as Mike Greenwell and Tim Naehring were also semi-regulars.

When Beer Works first opened, Steve Slesar said he hoped to brew about 1,500 barrels of beer that first year, the same as the Commonwealth Brewing Company, but within nine months, the company had brewed 2,300 barrels.

"We worked our butts off," said Steve Slesar. "We worked a lot of hours. It was crazy. Each month was getting busier and busier. I looked at the consumption and wondered how I was going to keep it up. But when the Red Sox went on a road trip, it allowed us to catch up. We brewed 225 days that year. That was about twice as much as I thought we'd have to brew. It was mayhem."

The location was much better than expected, and the Beer Works' main competition, the Commonwealth Brewing Company, was completely different. It concentrated on English ales served on cask. Although that earned the company critical acclaim, in the early days of craft beer in Boston, it was hard to sell a beer that a lot of people think is warm and flat.

Boston Beer Works gave an alternative to those who wanted good beer but weren't necessarily into cask beer.

"When we opened up, it answered a pent-up demand," said Slesar. "It was the start of people who wanted craft beer. People appreciated beer. It was a learning curve for the public and for us. We just continued to brew a lot of beer. It was new and interesting. Commonwealth was doing the whole English beer, beer engine thing. It's too limited for the American market. We actually have cask beer to this day, but it's not the whole selection for us."

However, even though the business was good, an outside force put Boston Beer Works in danger. Boston Beer Works opened on April 10, 1992. That day, Joe and Steve Slesar, along with family and friends, were celebrating the busy opening when Boston Beer Company (Samuel Adams) founder Jim Koch stopped in. Steve Slesar said he had recognized Jim Koch and went over to introduce himself.

"I said, 'Hi Jim, how are you doing,'" said Steve Slesar. "He said, 'Is this your place?' and when I said yes, he said, 'You can't use the name, I trademarked Boston Beer.' He started ripping me. He kind of stormed out of here."

On April 14, Boston Beer Company filed for a temporary restraining order to block the Beer Works from using its name, claiming that the Boston Beer Works name was infringing on its trademark of Boston Beer Company. A judge denied the request and later denied an injunction request. Boston Beer Company then filed a federal trademark suit.

In the suit, Boston Beer Company said, "Adoption of 'Boston Beer Works' made with knowledge of Plaintiff's prior use of the trademark and trade name 'Boston' and its 'Boston brand' family of trademarks…" constitutes a violation of trademark law.

Boston Beer Company lost the trademark infringement suit in U.S. District Court when a judge ruled that the Boston Beer Company, which was marketed mostly as Samuel Adams, failed to prove that "Boston Beer" had taken on a secondary meaning synonymous only with its beers.

Boston Beer Company appealed all the way to the U.S. Court of Appeals, but in 1993, it lost its last appeal, allowing Boston Beer Works to keep its name in what was quickly becoming a popular destination for beer lovers and sports fans alike.

"That thing cost us $75,000 right out of the gate," said Steve Slesar. "It was ridiculous. We had to fight it just on principal. When Samuel Adams went public, I bought $1,500 worth of shares at $16 and sold them at $35. It wasn't a huge amount of money, but it was my way of getting back at Jim Koch."

Despite the legal problems, business was booming for the Slesars. They continued to add draft lines, going from eight to twelve and eventually sixteen (today it its twenty to twenty-two), and they decided to expand the brand. In 1996, they purchased a failing brewpub in Salem, and in 2001, the brothers again expanded, opening a second Boston Beer Works, this time across from the TD Bank Garden on Canal Street. During that time, they bought out Kadish from the business.

"Just like Fenway, that area isn't what it is today," said Joe Slesar. "There wasn't a development boom. There were no calls for businesses. All of the buildings were dilapidated. It was pretty gritty. That's the best way to put it. I ended up buying a building near the Garden. We ended up buying up a building. We mortgaged ourselves again. We built the Beer Works on Canal Street and a lot of office space."

Like the Fenway location, the Canal Street Beer Works was doing a brisk business. The two Boston brewpubs, as well as the Salem Beer Works, now had about sixteen beers on tap each, with separate brewers at each location. The brewers had creativity to create their own beers but also shared some of the same recipes. The beers were also branded differently for each location. Some beers near Fenway Park have baseball-themed names, like Fenway

American Pale Ale, while the Canal Street location's beer names may be inspired by the Boston Celtics or Boston Bruins (Boston Garden Golden). The Salem location's names tended toward the town's history of witches, with names like Witch City Red.

From 2001 through 2007, the Slesars continued on with just those locations, but in 2007, they reached a crossroads.

It was that expansion that really began to put a strain on the brothers, Steve Slesar said. The Canal Street location took years to open. Although they bought the building in 1997, they could not open the brewpub until 2001. They also opened up another restaurant, the B.B. Wolf, which ultimately failed.

"We wanted to go on different paths," said Joe Slesar. "I wanted to grow; he didn't want to."

Steve Slesar said he was being pulled further and further away from the brewing aspect of Beer Works. Joe Slesar wanted to add more restaurants, but Steve Slesar did not.

"I got pulled out of the brewery a lot to work at the front of the store," said Steve Slesar. "The infrastructure on the management side was the real weak link. I don't know if Joe would admit to that. We turned out so many managers it was hard to keep them. I got sucked to the front of the house, and I hated it. Whenever a manager left Salem, I had to go and run it. My wife even got sucked in and had to manage sometimes. Joe wanted to open up ten stores and go public and all of these great things. It was fracturing the business."

The brothers decided to sell Beer Works, but when a third-party sale fell through, Joe Slesar bought out his younger brother in February 2007. Steve Slesar had bought a restaurant in Medfield, the Noon Hill Grill, which he still owns.

Now, the brothers get along and see each other throughout the year, but at first, things weren't the best.

"There was a cooling-off period," said Steve Slesar. "I wasn't happy about being bought out."

Now running the business alone, Joe Slesar bought the former Mill Brewing Company in Lowell, building a new brewpub as well as a production facility that bottled three of the Beer Works most popular beers, the Fenway American Pale Ale, the Bunker Hill Bluebeery Ale and the original beer, the Boston Red Ale.

Joe Slesar flirted with expanding Beer Works nationally, like the Cambridge-based John Harvard's chain. He even put in a bid for a site

across from Wrigley Park, the home of the Chicago Cubs, but lost out to Goose Island. Looking back, Slesar said that was good for Beer Works.

"It would have been cool to have a Chicago Beer Works," he said. "We made some good decisions, and we got lucky. If we went to Chicago, who knows where we would be today? We stayed here and we have stayed focused. We're in the restaurant business and the brewery business. We got into the restaurant and brewery business to stay in and not come out of it. Other owners, they came in to try to make a bazillion dollars planning to get out. They didn't stay focused."

In 2010, Beer Works expanded again, opening up a location in Hingham. In 2013, it opened up the Framingham location.

Beer Works beer is also potentially the first Boston-made product you see when arriving in Boston and the last before leaving the city.

"We opened in Logan," said Joe Slesar. "We're right near United and Jet Blue, so tourists and Boston people going into the airport and leaving are drinking Beer Works beer."

Beer Works survived the late 1990s, which saw many Boston-area brewpubs (as well as breweries and brewpubs around the country) fail and disappear. Joe Slesar said the location helped, but it was more than that. They wanted to make Beer Works accessible for more than beer geeks.

"We never looked at limiting ourselves to one segment," said Joe Slesar. "We're not a sports bar, although we do have the games on. We're not just a beer place although we have good beer. We care about our food. We're not about just twenty-five-years-olds. We have families come in and have fun. We have a very diverse audience. We knew we were going to be busy on game days. The goal was to be busy when there was no game. We want to be known for having great beer and great food. We make our food by hand; we make our beer by hand. We think we have a good operation. We think we have a good concept. We think there's more opportunity."

Because Beer Works has been around for a long time, people tend to forget how much it has pushed the boundaries throughout the years, Joe Slesar said. Throughout the years, the various brewers have experimented with various ingredients (potatoes, watermelon, etc.) and various styles of beer (sour beers, barleywines and Belgian quads) and consistently brew a popular IPA.

The key, Joe Slesar said, was not caring what others were saying about the beers.

"We were the ones who were pushing the envelope," said Slesar. "We were the ones who did a blueberry beer, and people sneered and said 'That's

stupid, it won't work.' Well, people like it, so it's not that stupid. We are constantly trying to reinvent and evolve. We don't sit around and do the same thing every day. We continually think about what we can do better."

Steve Slesar said he brewed the first New England blueberry beer after he tried one on a trip to California. When he told his brewing peers about the beer, he was met with disbelief.

"I let it sit for a week because I didn't have the courage to sell it," said Steve Slesar. "Everyone told me, 'What is this, shampoo?' People told me I was ruining beer. Today, one of every four beers sold at Beer Works is a Bluebeery."

Other early beers that Steve Slesar said he brewed and introduced to New England is a pumpkin beer and an early West Coast–style IPA, which he said predates Harpoon's version by a few months.

"We really had the beer cranking," he said. "We were balls to the wall. People came to visit us from all over the country. I had a great brewing staff. Our beer was fresh. Freshness was key."

An example of that effort to do better is how Beer Works takes advantage of having numerous brewers at its various pubs. Yes, Beer Works is a chain, and the food menu is similar at each location, but the brewers have a lot of creative control at the various pubs. It works more as a brewing collaborative rather than a chain.

Each brewpub will have some set beers, such as the Bluebeery and the other original beers, but the brewers have control to fill up the rest of the twenty-two draft lines with various beers. For example, they have to have an IPA, but it won't be the same IPA—different hops and malts may be used.

Brewers can create different stouts, porters, wheat beers, pale ales, fruit beers or anything they think will work. They can also brew higher-octane beers or experimental beers. If the beers are popular enough, such as the Double Apricot Saison, originally brewed in Framingham, the other locations can either brew it themselves or the beer will be brewed in a larger amount in Framingham and then sent to the other locations. The Lowell packaging plant also has several oak barrels. This allows the individual brewers to be able to create barrel-aged beers without having to find space for the large barrels in their individual pubs.

The brewpubs also have three different sections of a beer menu, including the so-called normal beers, that are split into three categories: "Light and Golden," "Pale and Amber" and "Dark Beers." The menu also features various seasonal beers, appropriate for the time of year when available. The watermelon ale, served with a slice of watermelon on the side of the glass, is a particularly huge hit. Then there are the monthly special beers. Beer

Works will often have themed months, such as Belgian beers in January or German beers in October. Then there is the Overtime Series, which features more experimental beers, such as the Redeemer, a hoppy imperial red, or the Black-o-Lantern, an imperial pumpkin stout.

"We give our brewers a lot of room to create," said Joe Slesar. "We have our mainstays, like an IPA and a blueberry, but because we have twenty beers on tap, we give our brewers a lot of time to try new things."

Beer Works is also putting the push on expanding its bottling plans. Originally, only the three longtime favorites were available, but in 2013, it expanded to include three seasonal beers (Summer Works Watermelon, Autumn Works Pumpkin and Winter Works Lovefest, which is a chocolate-strawberry stout).

It also introduced the Overtime Series in bottles. The Overtime beers included the RIPA, a double IPA brewed with rosemary, the Black-o-Lantern and the Redeemer.

"There's room in the packaging side to expand," said Joe Slesar. "We just scratched the tip of the iceberg with our bottles. It's about quality and it's about value."

In 2014, for the first time, people will be able to get Beer Works beers on draft without being in a Beer Works pub. Joe Slesar said Beer Works kegs will be sent to the distributors and will soon be seen all over Massachusetts.

Beer Works is not just about beer. It is also a very popular dining destination. The pubs have the standard fare of burgers, nachos and wings but also have more unusual menu items such as Bluebeery Shark, an appetizer side plate of grilled mako shark drizzled with a blueberry gastrique, or the potato-bacon-cheddar spring rolls. Entrees include fish and chips, beer-basted BBQ steak tips, shrimp and ham mac 'n cheese and the maple-roasted statler chicken. It also has lunch specials, a full dessert menu and a brunch menu that is available on Saturday and Sundays.

Despite the success, Joe Slesar said he is not resting and is always looking for more opportunities.

"I'm a little diversified," he said. "We own six restaurants. I have all of the office space. We're financially stable and strong. We think we have a good operation. We think we have a good concept. There's opportunity to grow."

That growing may be in the form of more pubs throughout Massachusetts and possibly other locations in New England, Joe Slesar said.

Steve Slesar said one of the things he is most proud of from his time at Beer Works are some of the brewers who got their start under him and have gone on to their own operations, such as Jack Hendler, who owns Jack's

Abby Brewing in Framingham, Massachusetts, and Scott Houghton, co-owner of the Battle Road Brewing Company, a Lexington-based contract brewer. Another brewer, John Kimmich, founder of the Alchemist Brewery in Vermont (and the brewer of one of the most highly regarded beers in the world, Heady Topper), also brewed at Beer Works under Slesar.

Although not happy about leaving Beer Works originally, Steve Slesar said it was the best thing that could have happened to him.

"I left Beer Works in February 2007, and in February 2008, my son was born," he said. "I've spent every day of my son's life with him, from the day he was born until the day he got on the bus for the first day of kindergarten. I wouldn't trade that for anything. I wouldn't have been able to do that if I was still at Beer Works."

Not that brewing hasn't crossed his mind.

"Every month, someone calls me about a building, or I'll drive by some place and think, 'That would be good for a brewery.' A start-up would take a lot of work. I got a couple of ideas in my head and my wife is like, 'You have to do that.'"

Along with the good food and beer, Joe Slesar said the key to success over the years has been good business sense. The three most successful beer businesses in Boston—Samuel Adams, Harpoon Brewery and Boston Beer Works—were all started by people who had MBAs. Often, he said, those seeking to open a brewpub or brewery have trouble handling the business side, which is just as important as everything else.

"What people don't realize, whether they are starting a brewery or a restaurant or whatever, is there are other things you have to do," he said. "You can have the best beer and still fail. You can have the best food and still fail. You have to be able to do it all and you have to be able to do it well. We do that."

THE MISSING BREWERIES
OF THE 1990S

In 1993, the Boston brewing scene had seemingly taken off. Boston Beer Company (aka Samuel Adams) was one of the largest craft breweries in the world. The Harpoon Brewery had hit its stride. The Commonwealth Brewing Company was one of the most respected brewpubs in the country, and the Boston Beer Works was new but was packed day in and day out, quickly becoming a game-day destination for beer drinkers.

And then in 1994, the Tremont Brewery opened up in Charlestown. It was only the third production brewery to open in Boston since Haffenreffer went out of business in 1964.

More brewpubs followed—Back Bay Brewing Company (same owner as what had been renamed Commonwealth Fish & Beer Company), Rock Bottom, Fort Hill Brewhouse and then North East Brewing Company. Boston suddenly had a beer scene consisting of mostly young brewers.

But by the end of 2002, only Boston Beer Works, Harpoon and Samuel Adams remained. All of the others closed. Another brewery would not open in the city until 2013.

Several of those who brewed in the 1990s still have strong memories of the time. Some look back at it with pride, while others don't remember it fondly. The brewers all got along. They had fun hanging out together, brewing beer no one had ever had before and just being part of what looked like a brewing revolution.

That fraternity of young brewers from Boston and the nearby communities of Cambridge and Waltham often met once a month at Red

Tremont Brewing Company started in 1993 and lasted into the early 2000s before being sold. *Photo courtesy of Chris Lohring.*

Bones, a popular barbecue joint in Somerville with a good selection of beer and good food.

"They used to have these brewers nights where anyone who was a professional brewer could come in and eat downstairs for free," said Dann Paquette, who was brewer at the North East Brewing Company in the 1990s. "The whole downstairs was full of brewers. You became good friends. Even today, I'm good friends with Tod [Mott] and Will Meyers [Cambridge Brewing Company brewmaster]."

"We all hung out and shared a lot of stories and drank a lot of beer and had a lot of fun," said Chris Lohring, former owner/brewer of the now defunct Tremont Brewing Company.

Mott said, "We had a blast. It was a great community. The community is still strong. There are a handful of assholes, but it's great."

The quality of beers being brewed was also high and would still compete with what is being brewed today, Lohring said.

"When you think about the early days, there was some great stuff being made," he said. "Dann was doing incredible things at North East. Boston Beer Works, the early crews at the Fenway locations, were doing some great things."

But it wasn't all fun. Not everyone liked the beer that was being offered. Businesses began to close, and brewers were often broke.

"When people got out of the business, they didn't see the future in the business," said Paquette, who is now the owner of Pretty Things Beer & Ale Project, a popular tenant brewer based in Massachusetts. "I'd say 80 percent of the people from back then are out of the industry, and these were hardcore people. Darryl Goss [Cambridge Brewing Company] and Jeff

Charnick died. These guys were the big guns on the scene like Tod [Mott] and Al Marzi [current Harpoon Brewery chief brewing officer]."

Lohring said, "If you look back and remember, in the late 1990s and early 2000s, craft beer went flat. It [the industry] was so young and people thought it was a fad. I went to three or four brewery auctions within six months and I had to stop going. It was depressing. These were people I didn't know, but they were doing the same thing I was doing."

Here's a look back at these lost breweries.

Commonwealth Brewing Company and Back Bay Brewing Company

Tod Mott was already well known in Boston. He was the head brewer at the Harpoon Brewery in 1993 and brewed the Harpoon IPA, today one of the best-selling craft beers in the country. But working at a big brewery where he wasn't in control wasn't something he wanted to do.

At the same time, the Commonwealth Brewing Company, located on Portland Street near what was then known as the Fleet Center (now the TD Garden), offered the perfect alternative. This brewpub, opened in 1986 by an Englishman named Richard Wrigley and his partners, Jeff and Jim Lee, had developed a reputation of brewing good beer and having great food.

In 1993, Tod Mott joined the Commonwealth Brewing Company, becoming head brewer. He had joined a long line of brewers that included Jeff Charnick; Steve Slesar, who, along with his brother, started Boston Beer Works; Phil Leinart, currently of Brewery Ommegang in Cooperstown, New York; John Mallett, currently of Bells Brewery in Kalamazoo, Michigan; and Dan Kramer, currently of Element Brewing Company in Millers Falls, Massachusetts.

"A brewpub let you be much more artisanal, which appealed to me," said Mott. "The Commonwealth Brewing Company was doing nothing but cask-conditioned beer. I think a lot of the brewpubs back then were ahead of their times. I got to Commonwealth and I was in my glory."

By that time, the Commonwealth Brewing Company was owned by Joe Quattrocchi, and Mott and his crew were turning out well-respected English-style ales served on cask. The owner later renamed it the Commonwealth Fish & Beer Company.

"Commonwealth Brewing was one of the greatest brewpubs in the history of the United States," Paquette said.

"Commonwealth, if you had never been there, you don't know what was going on," said Lohring, who founded the Tremont Brewing Company with Alex Reveliotty in 1993. "I miss that place terribly."

In 1995, Quattrocchi founded Back Bay Brewing Company on Newbury Street, and Mott became the brewing manager for both that and Commonwealth.

"Back Bay was incredible," said Mott. "We were so far ahead of the curve. The beer was great, but the food was outstanding. Chef Ed Doyle was really making great food. We were the first gastro pub. I think the brewpubs back then would be doing a lot better now."

However, Quattrocchi saw an opportunity to make even more money if he got rid of the brewing equipment and maximized the space in his two restaurants, both of which were in high-priced locations.

"He really wasn't a beer drinker, and he saw an opportunity to make more money," said Mott. "The space, the retail space the brewery occupied, could be used for tables without all of the extra expenses of brewing beer. A lot of people saw big money, but the return is not that quick. It's more about the lifestyle."

In an interview with the *Boston Business Journal* in a 2000 article about him closing Back Bay, Quattrocchi said business just wasn't good enough. When he converted to a restaurant called Vox Populi, business jumped up 40 percent.

"We think the brewery restaurants really are just not hot anymore," Quattrocchi told the *Boston Business Journal.*

Jason and Todd Alstrom, a pair of brothers who started the popular beer website beeradvocate.com, lamented what they saw as the end of Commonwealth in a 2001 article they wrote for their site, blaming Quattrocchi.

"If he has his way, America will lose one of its earliest brewpubs and a great contribution to the brewing industry," they said.

And much to the chagrin of the fans of both brewpubs, both closed. Back Bay closed in 2000, while Commonwealth struggled on until 2002 before it also closed its doors, as the Alstroms predicted.

"There were too many restaurant people involved. Commonwealth and Back Bay should not have gone anywhere," said Paquette. "They should still be here today. I miss—I wish Tod Mott was still here [in Boston]. I wish Commonwealth was still here."

Lohring said the slowdown in the 2000s really showed whether owners were in it for the money or for the beer. He said Quattrocchi was one who appeared to be in the business for the wrong reason.

"He just decided to shut down Commonwealth and Back Bay and move on to a new gimmick," he said. "We weeded out a lot of people who weren't beer people."

Mott continued his brewing career after leaving Boston. He moved on to Quincy Ships in nearby Quincy, but that brewpub also went out of business. He also moved on to the Tap, a brewpub about an hour from Boston in Haverhill, Massachusetts.

From there, he moved on to the Portsmouth Brewery in Portsmouth, New Hampshire, where he earned acclaim nationally in the beer world with his popular Kate the Great Russian Imperial Stout, which earned the "Top Beer in the World" honors from beeradvocate.com users. He has since left the Portsmouth Brewery and is set to open up his own brewery, the Tributary Brewing Company, in Kittery, Maine, in the summer of 2014.

Mott relishes the idea of having his own production brewery for the first time in his life.

"People say it's not a job, and it's true. It's an education. You're learning something new every day, and I'm still learning," said Mott. "I wish I got out of Portsmouth about five years earlier. I'm fifty-six, and I got ten good years left."

Tremont Brewing Company

Until 1993, there were still only two production breweries in Boston: Harpoon and Boston Beer Company. That changed when Chris Lohring and Alex Reveliotty decided to open up the Atlantic Coast Brewing Company in the Charlestown section of Boston, the first brewery there since the Commercial Brewery closed in 1940.

Better known as the Tremont Brewing Company, it, like many of the New England breweries at the time, focused on English-style ales. Lohring, a graduate of the Siebel Institute of Technology's brewing program, was the head brewer for the upstart brewery.

"They were ahead of their time," said Mott, who was in the midst of creating the Harpoon IPA and getting ready to leave Harpoon to go to Commonwealth when Tremont first started. "They were doing a lot of cask-conditioned ales. If they were on the market today, they'd be killing it."

The founders both came from very different backgrounds. Reveliotty was a former computer consultant, while Lohring was a student at Northeastern

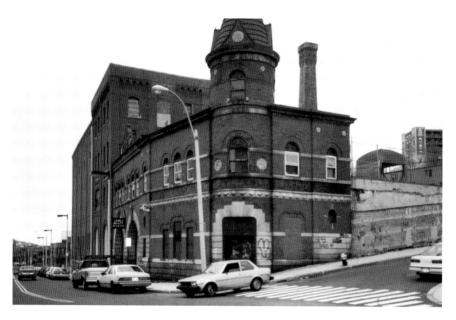

The Tremont Brewing Company was located in Charlestown next to a storage facility. *Photo courtesy of Chris Lohring.*

Chris Lohring samples some Tremont beer in the halls of the brewery. *Photo courtesy of Chris Lohring.*

University who was analyzing a microbrewery feasibility project, according to a 1996 *Boston Business Journal* article. They met in 1992, started the brewery in 1993 and poured its first beers in April 1994.

The two raised more than $700,000 from friends, family and a bank loan to start the brewery. Reveliotty toured breweries in the United States and England to learn about the brewing industry, while Lohring learned brewing at the Kennebunkport Brewing Company in Maine, according to the *Boston Business Journal* article.

The first batch of its Tremont Ale was well received. It was poured at the Boston Brewer's Festival at the World Trade Center, and the *Yankee Brew News* named it the "best new beer" in New England, according to the *Boston Business Journal*.

The Tremont Brewing Company was a small production brewery. Although the industry was still relatively young, it helped that Tremont wasn't the first Boston brewery.

"It was a much different time," said Lohring, who now owns Notch Brewing, which focuses on low-alcohol "session" beers. "There weren't a lot of resources. We benefited from the few guys who had been at it before us. Because of the scarcity of equipment, raw materials and just plain knowledge, you relied on others who were doing the same thing. We spoke to Tod and Jeff [Charnick], who was brewing at Commonwealth. We spoke to the Harpoon brewers. I have to say the guys at the Boston Beer Company, their R&D people, were very helpful to us. That's why we developed such a close fraternity."

Tremont's first beers hit the market in 1994, and it started with its flagship beer, the Tremont Ale, a classic English bitter. A year later, the IPA was released, and it was greeted with a positive review by beer writer Kerry Byrne in a 1995 *Yankee Brew News* article.

"The IPA is another successful venture into authentic English-style brewing by Atlantic Coast," Byrne wrote. "Earthy, almost grassy hop aromas with a beefy body to support it. Be careful with how much you drink; with an original gravity of 1063 and over 6 percent alcohol, it's not exactly a slug-em-in-the-sun summer brew."

Tremont continued to grow each year. It had a full line-up of beers and, along with Commonwealth, began having cask-conditioned ales available at local pubs. It also took part in many music events and early beer festivals.

"We were draft only for the first three years," said Lohring. "After year three, we were doing over three thousand barrels, only selling east of [Route] 128. That was our market. There was an opportunity. Back then, if you got a draft handle, you had it forever. There wasn't rotating drafts.

"We were the first ones that were doing cask conditioned ales on a distributing basis," he continued. "We set up the first three cask engines. Today, it's no big deal, but back then, it was hard to sell craft beer in a cask. We grew to become the second-largest brewer in Massachusetts behind Harpoon. We were self-distributing, and we started distributing beers for other brewers."

The success continued, and Tremont began adding more beers. It brewed an English IPA, a bottle-conditioned porter, a barleywine, an old ale, a brown ale and a summer beer. In 1997 or 1998, Lohring also brewed a big IPA for the first time. It was the last beer he brewed for Tremont after he relinquished the brewing duties to Jeff Yeager, who went on to work at the New Belgium Brewing Company in Colorado.

"I basically doubled our IPA recipe," said Lohring. "I didn't have the marketing mind to call it a double IPA."

Today, when a brewery is set to open, it can turn to social media for free marketing and to build up a following. But, in 1993, the Internet was not like it is today, and Twitter and Facebook were not a twinkle in anyone's eyes yet. Breweries had to work hard to get the word out and relied on word of mouth.

"This was pre-Internet," said Lohring. "It was pre-Web. It's almost like unrecorded history. We had a newsletter. There was no way to reach the consumer. When we were selling beers in the 1990s, it was educating people about…we didn't call it craft beer because that phrase wasn't invented yet…we were educating people on good beer."

While Tremont was steadily growing, more and more brewpubs—restaurants with their own on-site brewery—began to pop up more frequently.

Things were going good, and after three years, Tremont began bottling its beers and widening its distribution. At the time, Tremont Ale was the only beer completely brewed in Boston because Harpoon was bottling its beers in New York at the time.

Although everything on the surface seemed to be going great, it wasn't all roses and blooming hop flowers. The industry began to slow down. Brewpubs and breweries around the country were starting to feel a pinch. People began to lose interest in craft beer after a bunch of mediocre breweries began flooding the market with beer. Good beer began to get lost in the noise. Breweries began to close, a few here and there at first, but it began to snowball into an avalanche, and it seemed like there was near-daily closings.

"A lot of production breweries have small margins and you needed scale and you needed it fast. It was the first try for a lot of brewers," Lohring said.

Tremont co-founder Chris Lohring, left, helps package bottles of beer. *Photo courtesy of Chris Lohring.*

Cases of Tremont's beers prepared to go to market. *Photo courtesy of Chris Lohring.*

Famed beer writer Michael Jackson visited Tremont to sample its British-inspired ales. *Photo courtesy of Chris Lohring.*

Tremont had sold its distribution company and was concentrating on brewing. But in 1999 and 2000, the company noticed that the craft beer market, which had been booming, had started to slow down. That worried Lohring, Reveliotty and their investors.

"We got a little cold feet," said Lohring. "We eventually sold to Shipyard [Brewing Company, based in Portland, Maine]. I've always said we got out ugly. It was a long, protracted sale. If we had hung on for a couple of more years…"

Rich Doyle, co-founder of the Harpoon Brewery, said Tremont's failure came down to simple finances.

Tremont participated in many beer and music events. Here is Lohring on stage before an event. *Photo courtesy of Chris Lohring.*

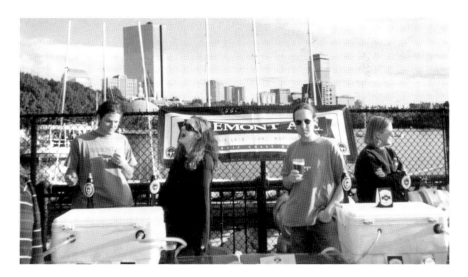

The Tremont crew at a beer tasting event. *Photo courtesy of Chris Lohring.*

"Tremont were some guys who tried to be a real brewery and they bottled a lot," said Doyle. "They had a nice business, but it didn't make enough money."

Lohring and Paquette both think that if Tremont had stayed afloat that it would be a 100,000-barrel-a-year brewery. Instead, Shipyard changed the recipes, added beers and pretty much made Tremont its own brand, with almost nothing left of the original Tremont. The beer wasn't good, and it wasn't what Lohring and Reveliotty created.

"People who remember Tremont don't really remember the beers I brewed," Lohring said. "I couldn't wait until Shipyard killed the brand."

In a 2006 interview with *Boston Magazine*, Lohring said he still hoped to bring Tremont back to Boston, despite the consistency problems with the beers being brewed in Maine.

"Draft has been a battle," Lohring says, "but bottle sales are doing well." And, like everybody else, he says, "we want to bring the brewing process back to Boston. We're actively looking."

Unfortunately, that never happened.

Today, Lohring is still involved in the beer world. In 2010, he founded Notch Brewing, which contract brews its beers out of Ipswich. All of his beers are "session beers," or low-alcohol beers that someone can have several of over a drinking session without getting drunk.

North East Brewing Company

In 1997, three friends, Bill Mason, Scott Patton and Mike Reardon, opened up the North East Brewing Company, a brewpub located in the Allston area of Boston.

They hired Dann Paquette as their head brewer. He had previously brewed at the Pilgrim Brewing Company, Mill City Brewing Company and then briefly at John Harvard's, which had plans to expand from Cambridge to Boston and numerous other locations throughout the country. Those plans fell through, but North East offered Paquette a chance to do some brewing.

"We were really ambitious," said Paquette. "It was a great place to be a brewer."

North East was doing many innovative beers, including lambics and other barrel-aged beers rarely seen outside of Belgium at the time.

"We would make adventurous beer here, and we'd be doing things different," said Paquette. "I got a lot of time to experiment. We did a lot of

barrel aging, which wasn't really done, so we were the leaders in that. We were doing some of the first wood-aged sour beers in the United States."

North East was a favorite of *Beer Advocate*, which wrote, "Brewer Dann Paquette brings classic ales and just some of the best damn beer you'll ever have to the area. He's a master of the Belgian style and makes an incredible Oak Cask-Condition Whiskey Porter. True craftsmanship at work."

In a 1996 article in *Yankee Brew News*, a free beer-centric newspaper, Paquette described his brewing philosophy.

"I'm trying to make distinctly malty beers," Paquette said in the article. "I don't think there's a brewery around here that focuses on malt. I thought it would be unique, and I happen to love malty beers."

Some of the early beers included the Lobsterback IPA, the Black Sow Stout, the MacFearsome Scotch and the Triple Black Wheat, which was made with black currants, black raspberries and blackberries.

"I didn't care how it came out, as long as it didn't taste like extract," Paquette said in the *Yankee Brew News* article.

Other beers from North East included the Bostonia Blonde (a kolsch), the Nor-Easer Pale Ale, St. Brendan's Bock, an Oktoberfest and a Bier de garde. Paquette even brewed a beer called Christmas Keeper, which was an old ale made with apricots and peppermint.

"You either loved it or hated it," Paquette said in a 1997 interview with *Yankee Brew News*. "But I was damned if I was going to do one of those cinnamon stick beers. Yet, a lot of people came in asking for a cinnamon or spiced beer and were mad that we didn't have one."

In a 2005 interview with *Massachusetts' Beverage Business* magazine, Paquette, then brewer at the Tap in Haverhill, spoke about his obsession with making everything as perfect as he could at North East.

"Back then, we wanted to do it right," he said. "We were really proud that we made actual lagers. Back then, everyone was making their 'Oktoberfests,' with quotes around it, right? Not really lagers. Everything's changed, but then we felt, we're not going to make a 'lager' unless it's really a lager. It was cool. I remember one time we had twelve beers on, five yeast strains represented. We had fun with it. For most of the year it was a jammin' place."

North East itself was a fairly large restaurant, with ten thousand square feet and 340 seats spread out over two floors. The pub featured wall-size windows open to the street and wood-burning fireplace, couches, coffee tables and board games, the *Yankee Brew News* article said.

There were two bars—one on the main level, which also housed the brewery right in the middle, as well as a bar in the basement.

"We wanted one very big room with a free-standing brewhouse in the middle," Patten told the *Yankee Brew News*. "People can sit here and eat and feel like they're part of the brewing process. You can come here five different times and feel like you've spent time in five different places."

Today, many breweries on the West Coast get a lot of credit for their Belgian-influenced beers, sour beers and barrel-aged beers and don't realize that those styles got their early starts in the United States in Boston, mainly by Paquette.

"Dann really pushed the limit early on," Lohring said.

"Boston was one of the first places where Belgian beers were brewed in the United States," Paquette said. "But anytime you sat down anywhere, people would say, 'You should go to Oregon. That's where the beer is really good.' I'm like, 'Shut the fuck up.' I think Boston was way ahead of its time. I had been to Portland, Oregon, in the time I was brewing beer. They had the same malts. It was all hoppy American pale ales or hoppy red ales. Back in the early days of the Great American Beer Festival, I certainly noticed a lot of the Boston breweries were bringing it. In 1998, I brought a lambic. Brew Moon then brought one. In 2001 or 2002, you started hearing about people making sour beers in California."

However, just because the beer was good doesn't mean North East was doing a booming business. The masses had not found their way to the small eatery with unique beers. Things weren't going well for North East.

"The three owners were men who worked on Wall Street and thought it would be kind of cool to own a brewpub," he said. "They treated it like a party palace for a few years and moved on. I wouldn't say we were doing terribly well. We were selling about ten barrels of beer a week. Back then, not a lot of people liked good beer. Seventy-five percent of people at our brewpub didn't want to drink the beer. When I started brewing, I was the only one drinking our beer. There were the wrong people running things. It's like the chicken and the egg."

It wasn't just North East that was feeling the pinch. Other Boston brewpubs were in trouble, too. Brew Moon, what appeared to be a popular brewpub in the Theater District that was part of a small chain, filed for Chapter 11 in 2000. In 2002, Rock Bottom bought it out and brewed beer there for about a decade, but now operates mainly as a restaurant.

It was a bleak time for Boston brewpubs.

"In 1999, 2000, there was a huge dip in craft beer drinking," said Paquette. "I kind of felt it and I thought it may be over."

Paquette, who also wrote for the *Yankee Brew News*, seemed to forecast the problems brewpubs would face in an article in January 1996. The article

mentioned that between 1989 and 1995 an average of 5 to 6 percent of all brewpubs in the country closed each year. New England, in that time period, did not have one closure.

"It's going to happen," Paquette wrote. "Brewpubs will close in New England. We're not immune."

North East closed its doors on New Year's Day in 2002. Paquette left to become a brewer in Concord and later at the Tap in Haverhill (after Mott). He eventually moved to England, where he met his wife, Martha.

Although he is still close with some people and proud of the beers he brewed, Paquette does not look on his time at North East and in Boston with fond memories.

"It did suck," said Paquette. "We had no medical coverage. At the end of the day, you'd be enjoying your beers, but no one else was. If I put together my worst five years, I would have made $14,000 total for those five years. I worked at start-ups. I lived at breweries. I'd sleep there, I'd brush my teeth there. I showered there, and then I'd brew there."

Today, Paquette and his wife run Pretty Things Beer & Ale Project. It's not a brick-and-mortar production brewery. Instead, they rent space from a brewery (typically Buzzards Bay in Westport), go there and brew their own beer. Pretty Things has earned a national reputation of putting out world-class beers, including American interpretations of Belgian-style ales and a series of historical beers.

Mott is a huge fan of what Paquette is doing today.

"He's just killing it," he said.

Fort Hill Brewhouse

The Fort Hill Brewhouse opened in 1996 on Broad Street and did not last long. Many blame the Big Dig for killing business to the pub.

According to a 1996 article by *Yankee Brew News*, Fort Hill was the smallest brewpub in Boston, seating only 125 people.

The small Fort Hill Brewpub opened in 1996. The brewpub was made out of reclaimed materials, brick, huge slabs of granite, hardwood and exposed beams of yellow pine wood.

"It seems the granite slabs and some of the timbers were part of the south battery sconce of a fort built on that location in 1630," *Yankee Brew News* writer Kerry Byrne wrote. "[Owner Christian] Strom, who used to own Ayer's Rock,

an Aussie-style pub across the street from Fort Hill Brewhouse, was more than happy to use the existing structures when he converted an old warehouse into the brewpub. Actually, he might not have had a choice. This place is SOLID."

The pub had a large twenty-barrel brewing system and focused on pizza for food. However, in 1997, it closed when the Big Dig, the large construction project that snarled traffic in Boston for more than a decade, began work in front of the brewpub.

The pub featured reclaimed materials for most of its décor, with granite slabs and timbers from a fort that was built in Massachusetts in 1630.

Brewer Mike Munroe offered up to eight beers at a time, including a light ale, a pale ale, a red ale, a brown ale, a porter, a raspberry ale, a Pilsner and its most popular beer, an IPA.

"I like to brew beers pretty true to style," Munroe, a former Commonwealth Brewing Company brewer, told the *Yankee Brew News*. "I'm a real hop head, so I love IPAs, ESBs and stouts. I'm trying to do a couple of low key beers, but on the rest, I'm not holding back."

Fort Hill Brewhouse closed in 1997. Today the Marc Harris Salon sits in its 125 Broad Street location.

Brew Moon/Rock Bottom

When Brew Moon opened its first Massachusetts brewpub on Stuart Street in 1994, it seemed like it had the formula to be a successful brewpub— good beer, good food and a busy location. More Brew Moons followed, with locations in Cambridge, Saugus and Braintree.

The Saugus Brew Moon was the second to open, in 1995, and was supposed to be the second of ten Brew Moons, according to a July 1995 article in the *Yankee Brew News*.

The article expressed its hopes that the new location did not experience the "kinks" the Boston location went through when it opened in 1994. By 1995, the article said the Boston location's beers had improved, although it seemed to be trying to "cater to the beer neophyte."

Six years after opening its first pub in Boston, Brew Moon filed Chapter 11. Rock Bottom, a national chain of brewpubs purchased it, and in 2002, the popular Brew Moon was no more.

"Our plan was to grow out at a faster rate than we did," Brew Moon chief financial officer Elliot Feiner told the *Boston Business Journal* in December

2000. "We couldn't raise enough capital to execute our business plan and then our overhead costs became too much to operate. You need more than five units to be successful."

After Brew Moon opened its four Massachusetts locations, the company opened up brewpubs in Pennsylvania and Hawaii.

Although Brew Moon failed, Feiner told the *Boston Business Journal* that the idea was solid.

"I don't think the brew pub concept is past its time," he said. "It's critical that it needs to provide good food and guest experiences. You can't just be a brew pub anymore."

The Rock Bottom continued on at the Brew Moon location, brewing beer for several years, before it stopped brewing beer onsite around 2010.

The Aftermath and What Is the Future for Boston

After all of the brewpubs and Tremont closed, something started to happen in Boston and the surrounding suburbs—people decided they did want to drink craft beer. However, they did not look for local beers. Instead, they looked to the influx of craft beers from other states.

Paquette calls it the "new wave" of craft beer fans, many of whom discovered craft beer after finding beeradvocate.com, a website dedicated to beer run by brothers Jason and Todd Alstrom.

"Frankly, I was pissed off," said Paquette. "Boston should be a great beer town. We had something going on that I thought was pretty good and then all of a sudden it was gone. It was an early version of the cocktail craze. People treated craft beer as this thing that happened before cocktails and people started going nuts for California breweries. These brewers were coming in from other places and they were rock stars. It was annoying, frankly."

Although Boston has many places where people can go to get a good beer, there is still a lack of Boston brewed beer, Lohring said.

"Everyone calls Boston a great beer town—that's bullshit," said Lohring. "If you have three production breweries, and nothing new has opened up for twenty years, there's something wrong."

Paquette said the big problem was that Boston beer fans used to look down on Boston-brewed beers, while revering the beers that were brewed elsewhere.

"People really slagged off Boston beer, and that still happens more in Boston than any other city," said Paquette. "We still like California beers. We have a lot of breweries in (Massachusetts). We have a lot of brands, a lot of contracting. They're super tiny. When you go to other cities around the country, there are big breweries. The thing you'll find in other parts of a country that you won't find here is you'll go to a beer bar, and all they'll have is local beer. You'll be at a bar in Denver, and you can buy a Great Divide, or an Oskar Blues or a New Belgium. In general, we need to be more supportive here."

Lohring said the new brewers who have started breweries or contract breweries around Boston should look to the past and see who came before them.

"Today you have more cliques," said Lohring. "You think you invented beer. You're stepping on the back of everyone before you. You may not agree with their path, but you can't really go forward without respecting them."

Mott agreed. "I think we basically paved the way for a lot of brewers today. It really comes down to quality, and we set the precedent for all of the people who are doing it today. A lot of the brewers I knew were in the brewpub scene. You wouldn't believe the number of brewers we had. A lot of people got into the movement and they will keep the movement going."

Thanks to social media such as Facebook and Twitter, and the Internet as a whole, those starting new breweries today have it easier, Lohring said.

"It's a totally different experience, and that's good," he said. "I don't want to say that as a negative. The amount of good beer being brewed today is unprecedented."

Boston's biggest problem is a lack of culture, Paquette said. It takes more than just people drinking beer to start a beer culture, but what he says is Boston's "transient culture" hurts.

"Here there's not a lot of continuity," said Paquette. "A lot of times, it's all about the new kid. There aren't a lot of beer writers who stay here for awhile. The beer buyers leave, and the new ones don't know you. In other places, they're there for years and you build a relationship. No one talks about industry here. We're all fighting for draft space out there and we really shouldn't be. If bars got off the California kick, there would be plenty of space for us all. In order for us to have a community, you can't have a constant revolving door for the beer buyers, for the beer writers, for the brewers. You have to have a constant five years before you can start building a community."

Paquette's statement almost mirrors thoughts of Jason and Todd Alstrom, founders of Beeradvocate.com, in a 2001 article they wrote for their website.

Unfortunately the support within Boston's brewing community is hardly reflected by the majority of its consumers. Even though beer has been described by many as the top beverage in Boston, most people haven't a clue as to Boston's vast brewing history, nor can they name the areas breweries and brewpubs, let alone pay a visit to them. They take local beer for granted and never think twice about what they drink—quick to fall for trendy adverts by mass-produced beer companies and mega-importers, setting aside local beer for mediocre beer with false appeal. All of this beer ignorance could very well drive our local breweries and brewpubs out of business and allow the bigger breweries to rule the shelves and kill the flavor of beer in Boston.

Both Paquette and Lohring think there could be more breweries in Boston.

"I think there's room for two or three more," said Paquette. "Boston itself is tough. It's a very residential city. It would be hard to find a place where you can put a production brewery. Property is expensive. You don't make a lot of money on beer. If you're going to make a salary and pay off your college loans, you need to get your beer in a lot of places."

Lohring said, "Doing business in Boston was difficult, and real estate is so expensive. It's going to have to be someone who really wants to be a production brewer."

Even Harpoon's Doyle said he can see more breweries coming to the Hub.

"I think it's cyclical," he said. "I think there will be a big boom and then a bust. The strong will survive and the weak will disappear."

A NEW FLOWER BLOOMS
IN BOSTON

TRILLIUM DEBUTS

Trillium Brewing Company is the newest brewery in Boston and is one of the darlings of the Massachusetts beer scene, brewing innovative and world-class beers in small batches.

But for husband-and-wife team J.C. and Esther Tetreault, opening their brewery in the Fort Point Channel neighborhood of Boston was a chore, dealing with years of red tape and roadblocks before finally opening its doors for business in March 2013 after initially planning on opening in 2011.

"We started planning in 2009," said Esther Tetreault. "We were connected with a real estate agent late in 2009. We have had this location since 2010. There was a lot of frustration for us. We had our space before a lot of other breweries that opened before us. We had our concept. We had our location, and we had our lease."

When Esther and J.C. Tetreault first began dating in the mid-2000s, opening a brewery wasn't something either of them planned. He was a scientist while she was in the midst of starting her own fitness business, which opened in 2006.

Although brewing wasn't something he knew about, J.C. Tetreault was a "better beer guy" when the pair started dating, Esther Tetreault said. He would be the guy who brought Guinness to a party rather than a case of Bud Light. A gift from Esther's mother to J.C. led to a light going off in his head.

"My mother bought him a home brewing kit," said Esther Tetreault. "He's a very creative person, and he really likes making things. The first

thing he brewed was a hard cider. My living room smelled like vomit for three months."

That first batch of cider then led to more batches of beer. An oatmeal porter was an early success, and in the first year of brewing, J.C. brewed twenty batches of beer.

"All of a sudden, our condo was taken over by beer," Esther Tetreault said. "He only did one or two batches of extract before he switched to whole grain."

In a 2013 interview with the *MetroWest Daily News*, J.C. Tetreault said, "I fell in love with beer first and then I fell in love with making beer. I quickly found that all of my free time was reading and practicing to make myself better at it."

Esther Tetreault said brewing beer connected to her husband's love of doing as much as he could by himself, without modern technology.

"He's very—he's all natural," Esther Tetreault said. "If he could have lived in the 1800s, he would have been happy. He would have loved to grow his own food, raise his own animals and make his own clothes. J.C. thinks the more rustic things are, the more refined he could be."

The couple got married in 2009, and J.C. Tetreault brewed all of the beer served at the reception. The wedding, held at the Saltwater Farms Vineyards in Connecticut, a small, family run but successful business, served as part of J.C. Tetreault's inspiration to open up a brewery.

The inspiration from the winery, combined with J.C. Tetreault being so happy that Esther Tetreault was running a business of her own that she loved, pushed him over the edge.

"He said he wanted to open up a brewery," said Esther Tetreault. "We're both ambitious go-getters, dreamers. We had a lot of energy. We had a lot of resources. We decided to see if we could make it work. If not, we can go back."

The couple picked the name for the brewery early on, Trillium, named for a flower that grows perennially in temperate regions of North America.

"It's very unique in symmetry and balance, what we strive for our beers to be," said J.C. "We're trying to reach that in our farmhouse ales."

Opposite, top: Trillium barrel ages many of its beers in its small Fort Point brewery. *Photo courtesy of Trillium.*

Opposite, bottom: Some of the brewing equipment at Trillium. *Photo courtesy of Trillium.*

Esther Tetreault said, "It is native to New England and it persisted through the industrial age. It's a hardy, native flower. It's symmetrical and simple and it stood out to him. It's simple, balanced and natural."

When J.C. and Esther Tetreault began planning their brewery, they spoke to several other people who were also in planning to open breweries. Although several of them were planning to open locations in the communities surrounding Boston, none were actually planning to open in the state's largest city.

There were only two breweries in the city—Harpoon and the Boston Beer Company (Samuel Adams)—and no brick-and-mortar production brewery had opened in the city since the Tremont Brewing Company closed in the early 2000s.

"It [a Boston brewery] wasn't initially the plan, but then the real estate agent came up with this space," said Esther. "We asked, 'Why aren't there other breweries in Boston?' I think the opportunity to brew in Boston was part of the appeal. This is how we would like to brew, by helping to revitalize a neighborhood that used to be home to several breweries. There were a lot of breweries down there. He [J.C.] began to fall in love with the romanticism of it. We just fell in love with the idea of what it could be."

After acquiring the space at 369 Congress Street in the Fort Point Channel neighborhood (located near the Seaport District and the Harpoon Brewery), things suddenly became very hard for the Tetreaults.

The city had not licensed a brewery for a decade and some consider the local government anti-alcohol. It took Trillium nine months to get a zoning variance to build the brewery, and another three months just to get an occupancy permit.

Then construction permits were slow in getting approved, adding even more delays. Trillium has low ceilings, the opposite of most breweries that have high ceilings to make sure there is enough room for all of the typical brewhouses and fermenters.

Instead, Trillium had to order shorter, wide tanks, as well as a glycol chiller most used in India to chill milk to keep it from spoiling. Although the space is small, the couple was able to fit several oak barrels inside the brewery to use to age special beers.

"We did a lot of DIY," said Esther. "This is 100 percent family owned. It's just us."

Trillium also put a lot of effort into their tasting room. All of the wooden tap handles are handmade by local wood craftsman Brian Smith from wood found inside the building, according to an interview with *Boston Magazine*.

Kegs of Trillium headed out to local bars. *Photo courtesy of Trillium.*

The large bar is made from the same reclaimed wooden beams removed in the building.

Even when they were about to open, Trillium ran into another problem—the city of Boston would not allow the brewery to pour samples, even though they are allowed under the state's Farmer/Brewers licenses. Both Harpoon (located on the same street) and Samuel Adams were allowed to pour samples. The beautiful tasting room became a retail shop.

On the surface, not being able to pour samples does not seem like a big deal. But Trillium opened only selling growlers, or sixty-four-ounce jugs of beer. That means a person would have to invest twenty dollars for a beer they could not try, a hurdle that worried the Tetreaults.

"The technical reason we couldn't pour samples was we did not have an [American with Disabilities Act] public bathroom," said Esther Tetreault. "We only wanted to do two-ounce samples, but the Board of Health felt like we were a place of consumption. It didn't make sense. You could go to liquor stores and get samples during tastings. You can go to yogurt shops and get samples. There was a lot of paperwork. It was frustrating. We hate that this [controversy] became part of us. The neighborhood has been great, there has always been a lot of support."

J.C. Tetreault told *Dig Boston* in March 2013 that the city ordering them to have a bathroom was impossible and unreasonable compared to other businesses that had alcohol samples but no bathrooms.

"A bathroom is not required by the city to do tastings for liquor stores," he said. "Nor bakeries or fro-yo places for that matter! We are not asking for a special consideration. We are not a restaurant…we are a retail shop. Of course we'd love to have a bathroom for the comfort of our guests (we have a bathroom in the production side of the space, where we have a pump-over ejection system for the sewerage and brewhouse floor drain). We were dealt an incredibly frustrating misinterpretation of code by someone in the city; we only expect (and deserve) a level playing field. There are wine/beer tastings in the convenience store/market in the very same building. They do not have an ADA bathroom."

But even without the samples, Esther Tetreault said they took a "leap of faith" and opened the doors in March, hoping that people would take a chance on buying growlers of their flagship beer, the self-named Trillium, a fabulous farmhouse-style ale.

"There is not much in it, just Pilsner and wheat malt—the layers and layers of complexity really arise from the mix of the different brewer's yeast," said J.C. Tetreault. "It's got quite a depth of character, but it's easy to enjoy if you're not a beer geek. It has a soft-pillowy mouth feel, but it's pretty aggressively hopped for the style."

In describing his idea about brewing beer, J.C. Tetreault said, "We're imagining what beers made here in America might be like if we had gone through the natural evolution of beer culture as experienced in the traditional beer countries of Europe," according to Kerry Byrne's April 2013 Fork Lift blog in the *Boston Herald*.

Tetreault said Trillium is a "decidedly American interpretation of traditional farmhouse ale. We've even cultured native microbes [yeasts] from the local area."

And people—a lot of people—took that leap and bought growlers of the beer.

"We got a really good reception," said Esther Tetreault. "People got really excited, and we got extremely good reviews. I didn't think we were going to do that type of business as soon as we did. I don't think anyone ever came in after buying a growler and said, 'You sold me a bad beer.'"

Along with growler fills, the brewery sold shirts and glasses, and its beers were available at a few select bars. Along with buying beer and Trillium gear, many visitors signed a petition asking for the city to allow two-ounce samples to be poured. Eventually, in November 2013, the city reversed course and

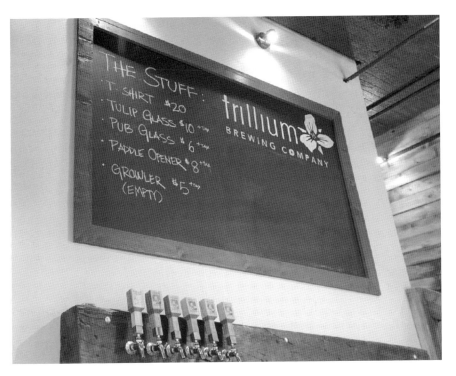

The blackboard informs people what is available each day in the tasting room/store. *Photo courtesy of Trillium.*

Trillium could pour samples. Now, patrons can visit the brewery Tuesday through Saturday, try any of the five beers available at any given time and buy either sixty-four-ounce or thirty-two-ounce growlers.

And by that time, Trillium had a lot of beers people wanted to try. J.C. Tetreault mimicked his home brewing output, brewing thirty beers in less than a year.

"J.C. always said he brews the beer he likes to drink," Esther said.

Many of the beers are like nothing being brewed in Boston—beers brewed with wild yeast and bacteria such as Bug Valley, Cuvee de Tetreault and New England Red. J.C. Tetreault also brews several beers with malt from Massachusetts maltster Valley Malt in Hadley, Massachusetts. Also popular is the Congress Street IPA, Broken Halo (Belgian strong ale), Little Rooster (pale ale) and Sunshower (saison).

Along with Trillium, other year-round beers include the Fort Point Pale Ale, a 6.5 percent alcohol by volume (ABV); a pale ale made with

T-shirts are some of the items available at Trillium. *Photo courtesy of Trillium.*

When Trillium first opened, the only way to bring its beer home was to buy it by the growler. *Photo courtesy of Trillium.*

Columbus and Citra hops; and the Wakerobin, a 7.4 percent ABV rye farmhouse red ale.

The other year-round beer is the Pot and Kettle, a 7.5 percent ABV oatmeal porter that is reminiscent of J.C. Tetreault's early homebrewed oatmeal porter he brewed in Esther Tetreault's condominium in 2005. At the end of 2013, the Pot and Kettle became Trillium's first bottled beers, available in 750-milliliter caged and corked bottles, available at a few select stores.

"It's been so positive," said Esther Tetreault. "We didn't plan on having this kind of demand."

In May 2013, Trillium brewed a very special beer called OneBoston. The collaboration beer, brewed with the Publick House (a renowned beer bar located in nearby Brookline), Jason and Todd Alstrom of Beer Advocate and Valley Malt, the IPA was released. The proceeds went to the One Fund Boston, a charity set up to help those affected by the Boston Marathon bombings earlier that year.

Trillium has made itself part of the Fort Point community and worked with several other community members to build the brewery and to get it where it is today.

According to the March 26, 2013 Honest Pint column in the *Dig Boston*, the large wooden bar is made from a wooden support beam from nearby 319 A Street that J.C. Tetreault and other volunteers carried to the brewery. The tap handles were created by South Boston–based Smith & Plank. The glycol chiller, used to control fermentation temperature, is a prototype milk chiller from Promethean Power Systems, another Fort Point Company. And when J.C. Tetreault was brewing test batches, Greentown Labs, a space for clean tech companies located around the corner from Trillium, allowed him to brew test batches there.

In January 2014, Trillium earned some national recognition from Rate Beer, a popular website with thousands of members who rate thousands of beers from around the world. It named Trillium the sixth best new brewery in the world to open in 2013, and it named it the best new brewery to open in the entire state of Massachusetts.

Because of that demand, the Tetreaults have reached their capacity of 1,200 barrels of beer that they can do in the brewery. Now, the Tetreaults are looking for a second location to give them more space and to allow them to continue to grow.

That doesn't mean that they will be leaving Boston and the neighborhood they love.

Trillium marks each of its growlers with a tab so you know exactly what you're getting. *Photo courtesy of Trillium.*

"We want to keep that location," said Esther Tetreault. "We want to stay in Fort Point."

Esther Tetreault said she never thought that when J.C. Tetreault brewed that first batch of beer that they would be married, have a child and be the proud owners of one of the few breweries in Boston.

"I had no idea that when he brewed his first batch back in 2005 that we would be at this point," she said. "I didn't think he had that entrepreneurial spirit. I see a lot of people who have a skill and are exceptional at that skill, but they don't have the business side of it down."

BEST PLACES TO GRAB A BEER IN BOSTON

BUKOWSKI'S TAVERN, 50 DALTON STREET

If you like bars with no frills, Bukowski's Tavern is the place for you. Bukowski's has a dive bar feel to it. But unlike your normal dive bar, this place (it has a sister location in nearby Cambridge) has a great beer selection. With more than twenty beers on draft, including the newest craft beer to hit the state, locals from Boston and surrounding suburbs and even Coors, this bar has beer for all tastes.

Along with the draft list, Bukowski's has a bottle list that features more than one hundred bottles and cans, including some hard-to-find Belgian ales. And if you're feeling adventurous, spin the wheel of beer and buy whatever beer it falls on.

As far as food, you can't go wrong with grabbing a Bukwoski's Mad Dog (hot dog) or an order of White Trash Cheese Dip, made with American cheese, green chilies, jalapeno peppers, diced tomatoes and diced onions.

JACOB WIRTH, 31 STUART STREET

One of the oldest bars in the city (founded in 1868) and the first bar to serve Budweiser, Jacob Wirth's is as close to being an authentic German restaurant as you'll find in Boston. Jacob Wirth's features thirty-two beers

on tap, including several German beers, as well as several Harpoon Brewery and Samuel Adams beers. Featuring hard wood floors and classic wooden furniture, Jacob Wirth is family friendly, particularly during the day. As for food, it's a mixture of both American and German cuisine—you can order some bratwursts or wiener schnitzel, as well as a Caesar salad.

PENGUIN PIZZA, 735 HUNTINGTON AVENUE

An out-of-the-way spot a lot of people may not know about, this is a destination worth seeking out. Penguin Pizza features some of the best beer you'll find in all of Boston. Along with your typical pepperoni or sausage pizza, why not order a duck confit pizza, or maybe a white pizza featuring freshly caught lobster?

The draft list only features about ten beers, but several of them are local craft options, and it also has fifty to sixty different bottle beers available at all times. You'll never have trouble finding the perfect beer to pair with the pizza of your choice.

STODDARD'S FINE FOOD & ALE, 44 TEMPLE PLACE

Stoddard's has a bit of a yuppie feel to it at times, but the beer selection is definitely nothing to sniff at. Stoddard's features twenty-two beers on draft, including a constant cask beer, as well as nearly seventy bottles. The selection is well thought out, featuring a mix of locals and nationals, and Stoddard's always seems to get a beer no one else has available in the city.

As for food, grab a bar favorite like deviled eggs or maybe an order of beef tartare. Or if you're in the mood for comfort food, the chicken potpie could be the perfect meal to make you feel like you're at home.

SUNSET GRILL & TAP, 130 BRIGHTON AVENUE

If you're a beer geek and live in Boston, chances are that you have been to the Sunset Grill at least once or fifty times in your life. This is *the* definitive

beer bar in Boston. The Sunset has 113 beers on tap and features a beer menu longer than some books that includes more than 300 bottles and cans. You can find beers from virtually every Massachusetts brewery, as well as beers from some of the top breweries in the United States, Belgium and England. It sometimes gets crowded with college kids, but who cares when the beer is that good.

The food is not that far off either. The Sunset features great wings, fabulous pulled pork and probably the best burgers in the city. And if you want something to share, the nacho plate is huge and rarely matched anywhere else.

BIBLIOGRAPHY

Acitelli, Tom. *The Audacity of Hops: The History of America's Craft Beer Revolution*. Chicago: Chicago Review Press, 2013.

American Antiquarian Society. "A Place of Reading: Revolutionary Taverns." Undated online publication.

Anderson, Will. *Beer New England*. Portland, ME: W. Anderson & Sons Pub., 1988.

Bacon, Edwin M. *Boston: A Guide Book*. Boston: Ginn and Company, 1903.

Baker, Andrew. *The Temperance Issue in the Election of 1840, Massachusetts*. Sturbridge, MA: Old Sturbridge Inc., n.d.

Block, James, David M. Fahey and Ian R. Tyrrell. *Alcohol and Temperance in Modern History: An International Encyclopedia*. Santa Barbara, CA, ABC Clio, 2003.

Conroy, David. *In Public Houses: Drink and the Revolution of Authority in Colonial Massachusetts*. Chapel Hill: University of North Carolina Press, 1995.

Drake, Samuel Adams, and Walter K. Watkins. *Old Tavern and Tavern Clubs*. Boston: W.A. Butterfield, 1886.

Dunn, John M. *Prohibition*. Independence, KY: Gale Group, 2010.

Miller, John C. *Sam Adams, Pioneer in Propaganda*. Redwood City, CA: Stanford University Press, 1936.

Nathan, Gavin. *Historic Taverns of Boston: 370 Years of Tavern History in One Definitive Guide*. Bloomington, IN: iUniverse Inc., 2006.

Nish, Dennis. *Prohibition*. Farmington Hills, MI: Greenhaven, 2003.

Ogle, Maureen. *Ambitious Brew*. New York: Mariner Books, 2006.

Okrents, Daniel. *Last Call: The Rise and Fall of Prohibition*. New York: Scribner, 2010.

Porter, Edward G. *Rambles in Old Boston*. Boston: Cupples, Upham and Company, 1886.

Smith, Gregg. *Beer in Amercica: The Early Years*. Boulder, CO: Brewers Publication, 1998.

Tremont Brewery. *Lost Brewery Tour Guide*. Boston: Self-published, 2000.

Archived materials from the Associated Press, Beeradvocate.com, *Boston Business Journal*, *Boston Magazine*, *Boston Phoenix*, *Boston Herald*, *Bloomberg Business Week*, CBS Boston, *Dig Boston*, *Harvard Graduates Magazine*, the Jamaica Plain Historical Socieity, *MetroWest Daily News*, *Modern Brewery Magazine*, *New York Times*, Serious Eats, the State University of New York, TeachHistory and *Yankee Brew News* were used in this book.

Images from the Boston Public Library's Flickr are used in keeping with the creators' Creative Commons licenses.

INDEX

ABOUT THE AUTHOR

Norman Miller grew up in the birthplace of Johnny Appleseed and plastic pink lawn flamingoes: Leominster, Massachusetts. Despite being a late bloomer as a beer drinker, he has been writing the Beer Nut column for the *MetroWest Daily News* in Framingham, Massachusetts, and the GateHouse Media family of newspapers since 2006, as well as a blog of the same name.

Currently, Norman lives in his childhood home in Leominster with his dog Foxy, his cats Trouble and Tweak and his prized possession, Beatrice the beer fridge, which is always stocked up with Boston beers.

Visit us at
www.historypress.net
..
This title is also available as an e-book